THIS BOOK

BELONGS TO

..

Thanks ever so much to each of my cherished readers for investing the time to read this book!

I know you could have picked from many other books, but you chose this one. So, a big thanks for reading all the way to the end. If you enjoyed this book or received value from it, I'd like to ask you for a favor. Please take a few minutes to **post an honest and heartfelt review on** Amazon.com. Your support does make a difference and helps to benefit other people.

Thanks!

Table of Contents

SUMMARY 1

tools & materials 26

crochet stitches 28

crochet techniques 35

finishing stitches 40

birman kitten 47

orange tabby kitten 56

bombay 65

persian 74

sphynx 82

munchkin 90

exotic shorthair 98

bengal 107

abyssinian 116

chartreux 125

abbreviations 133

SUMMARY

The Allure of Crafting with Cats in Crochet: Crafting with cats in crochet has become a popular trend among cat lovers and craft enthusiasts alike. The combination of two beloved hobbies - cats and crochet - has created a unique and captivating experience for those who indulge in this creative endeavor.

One of the main reasons why crafting with cats in crochet is so alluring is the undeniable charm and cuteness that cats bring to the table. Cats have a natural ability to captivate our attention with their playful antics and adorable expressions. When they are incorporated into crochet projects, they add an extra layer of charm and personality that is hard to resist. Whether it's a cat-shaped amigurumi or a cozy blanket adorned with cat motifs, these creations instantly become more endearing and appealing.

Another aspect that makes crafting with cats in crochet so appealing is the therapeutic and relaxing nature of both activities. Crocheting itself is known for its calming effects, as it requires focus and concentration, allowing the mind to unwind and find solace in the repetitive motions of the craft. Cats, on the other hand, are renowned for their soothing presence and ability to reduce stress. Combining these two activities creates a harmonious and tranquil environment, where the act of crocheting is enhanced by the comforting presence of a feline companion.

Crafting with cats in crochet also offers a unique opportunity for cat owners to bond with their pets on a deeper level. Cats are naturally curious creatures, and they often enjoy being involved in their owners' activities. By including them in the crochet process, cat owners can create a shared experience that strengthens their bond and creates

lasting memories. Whether it's watching their cat play with yarn or snuggling up together while working on a project, these moments of connection are priceless and add an extra layer of joy to the crafting process.

Furthermore, crafting with cats in crochet allows for endless creativity and personalization. Cat lovers can create a wide range of cat-themed items, from clothing and accessories to home decor and toys. The possibilities are only limited by one's imagination. Whether it's a cat-inspired sweater, a cat-shaped pillow, or a cat toy filled with catnip, these handmade creations allow cat owners to express their love for their feline friends in a tangible and artistic way.

In conclusion, the allure of crafting with cats in crochet lies in the combination of cuteness, relaxation, bonding, and creativity. It offers a unique and fulfilling experience for cat lovers and craft enthusiasts, allowing them to create beautiful and personalized items while enjoying the company of

Melding Love for Animals with Crochet Crafting:

A Perfect Blend of Creativity and Compassion

Crochet crafting has long been a beloved hobby for many individuals, allowing them to express their creativity and create beautiful and functional items. From cozy blankets to stylish accessories, the possibilities are endless. However, for those who have a deep love and appreciation for animals, crochet crafting can become so much more than just a hobby. It can be a way to combine their passion for animals with their creative skills, resulting in unique and meaningful creations.

One of the most popular ways to meld love for animals with crochet crafting is by making animal-inspired items. Whether it's a cute stuffed animal, a cozy pet bed, or even a fashionable animal-themed hat, these creations not only showcase the maker's crochet skills but also serve as a tribute to their favorite animals. By carefully selecting the right colors, textures, and patterns, crochet enthusiasts can bring their favorite animals to life in a tangible and huggable form.

Moreover, crochet crafting can also be used as a means to support animal welfare and conservation efforts. Many animal lovers choose to crochet items such as blankets, sweaters, and toys for animal shelters and rescue organizations. These handmade items provide comfort and warmth to animals in need, while also raising awareness about the importance of animal welfare. By donating their crochet creations, crafters can make a positive impact on the lives of animals and contribute to the larger cause of animal protection.

In addition to creating animal-inspired items and supporting animal welfare, crochet crafting can also be a way to raise funds for animal-related charities and organizations. Crafters can organize crochet sales, auctions, or even create online shops to sell their handmade creations. The proceeds from these sales can then be donated to animal shelters, wildlife conservation projects, or other initiatives aimed at protecting and preserving animals. This not only allows crafters to indulge in their passion for crochet but also enables them to make a tangible difference in the lives of animals.

Furthermore, crochet crafting can also be a therapeutic activity for individuals who have a deep connection with animals. The repetitive motions of crochet, combined with the focus and concentration required, can provide a sense of calm and relaxation. This can be particularly beneficial for those who may be dealing with stress, anxiety,

or other emotional challenges. By channeling their love for animals into their crochet projects, individuals can find solace and comfort, while also creating something beautiful and meaningful.

How to Make the Most of Animal Crochet: Animal crochet is a popular craft that allows you to create adorable and lifelike animals using yarn and a crochet hook. Whether you are a beginner or an experienced crocheter, there are several ways to make the most of animal crochet and create stunning pieces that will impress everyone.

First and foremost, it is important to choose the right materials for your animal crochet project. Opt for high-quality yarn that is soft and durable, as this will ensure that your finished piece looks and feels great. Additionally, select a crochet hook that is appropriate for the yarn you are using, as this will help you achieve the desired tension and stitch definition.

Once you have gathered your materials, it is time to choose a pattern for your animal crochet project. There are countless patterns available online and in crochet books, ranging from simple and beginner-friendly designs to more complex and intricate ones. Consider your skill level and the amount of time you are willing to invest in the project when selecting a pattern. It is also a good idea to read through the pattern thoroughly before starting, to ensure that you understand all the instructions and techniques involved.

When it comes to actually crocheting your animal, take your time and pay attention to detail. Start by creating a gauge swatch to ensure that your tension is consistent throughout the project. This will help your finished piece look more professional and polished. Additionally, use

stitch markers to keep track of your stitches and rounds, especially if you are working on a pattern that requires frequent increases or decreases.

To make your animal crochet project even more lifelike, consider adding details such as eyes, noses, and mouths. You can use safety eyes or sew-on eyes, depending on your preference and the look you are going for. Embroider or sew on noses and mouths using embroidery floss or yarn in a contrasting color. These small details can make a big difference in the overall appearance of your finished animal.

Once you have completed your animal crochet project, take the time to block and finish it properly. Blocking involves wetting or steaming your crochet piece to shape it and even out any uneven stitches. This step can greatly enhance the overall look of your finished animal and give it a more professional finish. Additionally, weave in any loose ends and trim them neatly to ensure that your piece looks clean and tidy.

Embarking on a Joyful Feline Crochet Journey: Embarking on a Joyful Feline Crochet Journey is an exciting and fulfilling endeavor that allows individuals to explore their creativity and passion for both crafting and cats. Crochet, a versatile and popular needlework technique, offers endless possibilities for creating adorable and unique feline-inspired projects.

The journey begins with gathering the necessary materials, such as crochet hooks, yarn in various colors, and a pattern book or online resources for inspiration. It is important to choose high-quality materials to ensure the durability and longevity of the finished projects.

Additionally, selecting yarn in different textures and thicknesses can add depth and dimension to the creations.

Once the materials are ready, it's time to dive into the world of feline crochet patterns. From amigurumi cats to cat-themed accessories like hats, scarves, and even blankets, the options are vast and varied. Beginners can start with simple patterns, gradually progressing to more complex designs as their skills improve.

The process of crocheting a feline-inspired project involves following a pattern, which provides step-by-step instructions on how to create each stitch and shape. It is essential to pay attention to details such as stitch count, gauge, and tension to ensure the accuracy and consistency of the finished piece. Crocheting requires patience and practice, but the sense of accomplishment and satisfaction that comes with completing a project is truly rewarding.

As the journey progresses, crocheters can experiment with different techniques and modifications to personalize their creations. Adding embellishments like buttons, ribbons, or embroidery can enhance the overall look and feel of the finished project. Additionally, incorporating different colors and patterns can bring out the unique personality of each feline-inspired creation.

Beyond the joy of creating beautiful and whimsical crochet pieces, this journey also offers an opportunity to connect with fellow crochet enthusiasts and cat lovers. Online communities, social media groups, and local crochet clubs provide a platform for sharing ideas, seeking advice, and showcasing completed projects. The sense of camaraderie and support within these communities can further enhance the overall experience of the feline crochet journey.

Moreover, this journey can also serve as a means of giving back to the feline community. Crocheted cat toys, blankets, and beds can be donated to animal shelters or rescue organizations, providing comfort and enrichment to cats in need. This act of kindness adds an extra layer of fulfillment and purpose to the crochet journey, knowing that the creations are making a positive impact on the lives of feline friends.

Overview of Animals Crochet: Techniques, Stitches, and Tools

Animals Crochet: Techniques, Stitches, and Tools is a comprehensive guidebook that provides an in-depth overview of the art of crocheting animals. Whether you are a beginner or an experienced crocheter, this book is designed to help you master the techniques, stitches, and tools necessary to create adorable crochet animals.

The book begins with an introduction to the basics of crochet, including an overview of the different types of yarn, hooks, and other tools that are commonly used in the craft. It also covers essential techniques such as how to hold the hook, how to make a slip knot, and how to create basic stitches like the chain stitch, single crochet, and double crochet.

Once you have a solid foundation in the basics, the book delves into more advanced techniques specific to crocheting animals. It provides step-by-step instructions on how to create various animal features such as ears, tails, and limbs, as well as how to assemble them to form a complete animal. The book also includes tips and tricks for adding details such as eyes, noses, and mouths to give your crochet animals a lifelike appearance.

In addition to the techniques, the book also features a wide range of animal patterns for you to try. From cute and cuddly teddy bears to fierce and majestic lions, there is a pattern for every animal lover. Each pattern includes detailed instructions, stitch counts, and color suggestions, making it easy for you to recreate the animals exactly as shown or add your own creative touches.

To further enhance your crochet skills, the book includes a section on advanced stitches and techniques that can be used to add texture and dimension to your crochet animals. From popcorn stitches to bobble stitches, these techniques will take your creations to the next level and make them truly unique.

Whether you are looking to create handmade gifts for loved ones or simply want to indulge in a relaxing and creative hobby, Animals Crochet: Techniques, Stitches, and Tools is the ultimate resource for all your crochet animal needs. With its detailed instructions, helpful tips, and inspiring patterns, this book will guide you on a journey to create beautiful and charming crochet animals that will bring joy to both yourself and others.

Materials, Yarn Selection, and Getting Started of Animal Crochet (Cat): When it comes to creating an adorable animal crochet project, such as a cat, there are a few key aspects to consider: the materials you will need, the yarn selection, and how to get started.

First and foremost, let's talk about the materials required for this project. You will need a crochet hook, preferably in a size suitable for the yarn you choose. Additionally, you will need a pair of scissors, a yarn needle for weaving in ends, and stuffing material to give your crochet cat its shape. It's also a good idea to have some stitch markers on hand to help keep track of your stitches.

Now, let's move on to the yarn selection. The type of yarn you choose will greatly impact the final look and feel of your crochet cat. For a soft and cuddly result, opt for a yarn made from natural fibers, such as cotton or bamboo. Acrylic yarn is also a popular choice due to its affordability and wide range of colors available. Consider the texture and thickness of the yarn as well, as this will affect the overall appearance of your cat. Thicker yarn will create a larger and more chunky cat, while thinner yarn will result in a more delicate and detailed finished product.

Once you have gathered your materials and selected your yarn, it's time to get started on your crochet cat. Begin by finding a pattern or tutorial that suits your skill level and desired outcome. There are countless resources available online, ranging from simple beginner-friendly patterns to more intricate designs for experienced crocheters. Make sure to read through the instructions carefully before starting, and take note of any special stitches or techniques that may be required.

As you begin crocheting, it's important to pay attention to your tension. Consistent tension will ensure that your stitches are even and your cat turns out symmetrical. If you find that your stitches are too tight or too loose, you may need to adjust your crochet hook size accordingly.

As you work through the pattern, be sure to take breaks and step back to assess your progress. This will help you catch any mistakes early on and make any necessary adjustments. Don't be afraid to unravel and redo sections if needed – it's all part of the learning process!

Once you have completed all the necessary crochet pieces for your cat, it's time to assemble them. Use your yarn needle to sew the various

parts together, following the pattern instructions. Take your time with this step to ensure that your cat is assembled securely and neatly.

Reading Patterns and Ensuring Successful Projects of Animal Crochet: Reading patterns is a crucial step in ensuring successful projects of animal crochet. Animal crochet patterns can be complex and intricate, requiring careful attention to detail and a thorough understanding of the instructions provided. By following the pattern accurately, crocheters can create beautiful and lifelike animal creations.

To begin, it is important to carefully read through the entire pattern before starting the project. This allows the crocheter to familiarize themselves with the overall structure of the animal and understand the different components that need to be crocheted. By having a clear understanding of the pattern, crocheters can plan their approach and ensure that they have all the necessary materials and skills to complete the project.

When reading the pattern, it is essential to pay close attention to the specific stitches and techniques that are required. Animal crochet patterns often include a variety of stitches, such as single crochet, double crochet, and slip stitch, among others. Each stitch contributes to the overall texture and appearance of the animal, so it is crucial to execute them correctly. Additionally, some patterns may incorporate more advanced techniques, such as color changes or working in the round, which require additional attention and practice.

Furthermore, understanding the abbreviations and symbols used in the pattern is essential for successful execution. Crochet patterns often use abbreviations to represent different stitches and techniques, which can be confusing for beginners. It is important to refer to the pattern's key

or a crochet stitch guide to ensure that the correct stitches are being used. Additionally, some patterns may include symbols or diagrams to illustrate specific steps or stitch placements. Taking the time to familiarize oneself with these symbols can greatly enhance comprehension and accuracy when following the pattern.

In addition to reading the pattern, it can be helpful to make notes or highlight important sections. This allows crocheters to easily reference specific instructions or keep track of their progress throughout the project. By annotating the pattern, crocheters can also identify any potential challenges or areas that require extra attention. This proactive approach can help prevent mistakes and ensure a smoother crocheting experience.

Lastly, it is important to approach the pattern with patience and perseverance. Animal crochet projects can be time-consuming and require a significant amount of effort. It is essential to take breaks when needed and not rush through the process. By maintaining a calm and focused mindset, crocheters can ensure that each stitch is executed accurately and that the final result is a successful and satisfying animal crochet project.

Tips, Tricks, and Troubleshooting in Animal Crochet: Tips, Tricks, and Troubleshooting in Animal Crochet is a comprehensive guide that aims to provide crochet enthusiasts with valuable insights and techniques to create adorable animal-themed crochet projects. Whether you are a beginner or an experienced crocheter, this guide is designed to help you enhance your skills and overcome common challenges that may arise during the process.

One of the key aspects covered in this guide is the selection of appropriate materials and tools for animal crochet projects. It delves into the importance of choosing the right yarn, hooks, and other accessories to achieve the desired results. Additionally, it provides tips on how to determine the appropriate yarn weight and hook size for different animal crochet patterns, ensuring that your finished projects have the desired shape and size.

The guide also offers a variety of tips and tricks to help you master the art of creating realistic animal features. It provides step-by-step instructions on how to crochet different animal body parts, such as ears, tails, and paws, with precision and accuracy. Furthermore, it explores various techniques to add texture and dimension to your animal crochet projects, such as using different stitch patterns and incorporating embellishments like buttons or beads.

Troubleshooting is another crucial aspect covered in this guide. It addresses common issues that crocheters may encounter while working on animal crochet projects and provides practical solutions to overcome them. Whether it's dealing with tension problems, unraveling stitches, or fixing mistakes, this guide offers troubleshooting tips to help you navigate through these challenges and achieve the desired results.

Moreover, this guide goes beyond the technical aspects of animal crochet and delves into the creative process. It provides inspiration and guidance on how to customize and personalize your animal crochet projects. From choosing unique color combinations to adding your own creative touches, this guide encourages you to unleash your imagination and create one-of-a-kind crochet animals that reflect your own style and personality.

In addition to the tips, tricks, and troubleshooting advice, this guide also includes a collection of animal crochet patterns. These patterns range from simple and beginner-friendly designs to more intricate and advanced projects. Each pattern is accompanied by detailed instructions, stitch diagrams, and full-color photographs, making it easy for you to follow along and create your own adorable crochet animals.

Overall, Tips, Tricks, and Troubleshooting in Animal Crochet is a comprehensive and invaluable resource for anyone interested in creating animal-themed crochet projects. Whether you are a novice or an experienced crocheter, this guide will equip you with the knowledge and skills needed to bring your

Project Introduction and Inspiration of Animal Crochet: Project Introduction:

The Animal Crochet project aims to bring the joy and creativity of crochet to the world of animals. Crochet is a versatile craft that involves creating fabric by interlocking loops of yarn with a crochet hook. It is a popular hobby among crafters and has been used to create a wide range of items such as clothing, accessories, and home decor. However, the Animal Crochet project takes this craft to a whole new level by focusing on creating adorable and lifelike animal-inspired crochet creations.

Inspiration:

The inspiration behind the Animal Crochet project stems from a deep love and appreciation for animals. Animals have always been a source of fascination and wonder for humans, and their unique characteristics and behaviors have often served as inspiration for various forms of art. Crochet, with its ability to create intricate and detailed designs, provides the perfect medium to capture the essence of animals in a tangible and visually appealing way.

The project draws inspiration from the vast diversity of animal species found in nature. From domestic pets like cats and dogs to exotic creatures like elephants and giraffes, the Animal Crochet project aims to showcase the beauty and charm of animals through the art of crochet. Each crochet creation is meticulously designed to capture the unique features and personality of the animal it represents, resulting in a truly lifelike and endearing finished product.

Furthermore, the Animal Crochet project also draws inspiration from the growing trend of amigurumi, a Japanese crochet technique that involves creating small, stuffed yarn creatures. Amigurumi has gained immense popularity in recent years, with crafters around the world creating adorable and cuddly creatures using this technique. The Animal Crochet project takes this concept a step further by focusing specifically on animal-inspired amigurumi, allowing crafters to bring their favorite animals to life through crochet.

In addition to the love for animals and the influence of amigurumi, the Animal Crochet project also aims to inspire creativity and provide a sense of accomplishment to crafters. Crochet is a highly versatile craft that allows for endless possibilities in terms of design and customization. By providing patterns and instructions for creating animal-inspired crochet creations, the project encourages crafters to explore their creativity and develop their crochet skills. The satisfaction of completing a crochet animal and seeing it come to life is a rewarding experience that can bring joy and a sense of achievement to both beginners and experienced crafters alike.

Detailed Material List and Yarn Recommendations of Animal Crochet: The detailed material list and yarn recommendations for animal crochet projects are essential for ensuring that you have all the necessary supplies to create your desired crochet animals. These lists provide you with a comprehensive overview of the materials needed, including the specific types of yarn that work best for each project.

When it comes to animal crochet, the material list typically includes items such as crochet hooks, stuffing, safety eyes or buttons for the eyes, and a yarn needle for sewing the pieces together. The crochet hooks needed will vary depending on the size of the yarn you choose to work with. For smaller animals, a smaller hook size, such as a 2.5mm or 3mm, is often recommended, while larger animals may require a 4mm or 5mm hook.

One of the most important aspects of animal crochet is selecting the right yarn. The type of yarn you choose can greatly impact the final look and feel of your crochet animals. Acrylic yarn is a popular choice for beginners as it is affordable, widely available, and easy to work with. It also comes in a wide range of colors, making it perfect for creating vibrant and playful animal designs.

However, if you're looking for a more luxurious and realistic finish, you may want to consider using natural fibers such as cotton or wool. Cotton yarn is known for its softness and durability, making it ideal for creating cuddly and huggable crochet animals. Wool yarn, on the other hand, has a natural warmth and texture that can add a lifelike quality to your creations.

In addition to the type of yarn, the weight or thickness of the yarn is also an important consideration. Thicker yarns, such as bulky or chunky

weight, are great for creating larger animals as they work up quickly and provide a more substantial finished product. On the other hand, thinner yarns, such as sport or fingering weight, are better suited for smaller animals as they allow for more intricate details and a finer finish.

When it comes to specific yarn recommendations, there are many trusted brands that offer a wide range of colors and textures suitable for animal crochet. Some popular choices include Red Heart Super Saver, Lion Brand Vanna's Choice, and Bernat Softee Baby. These brands offer a variety of yarn weights and colors, allowing you to find the perfect match for your animal crochet project.

In conclusion, the detailed material list and yarn recommendations for animal crochet are crucial for ensuring that you have all the necessary supplies to bring your

Comprehensive Pattern and Step-by-Step Instructions of Animal Crochet: The input is a comprehensive pattern and step-by-step instructions for creating animal crochet projects. This means that the instructions will guide the reader through the process of creating various crochet animals, providing them with all the necessary information and techniques required to successfully complete each project.

The pattern will include detailed descriptions of the materials needed, such as the type and weight of yarn, the size of crochet hooks, and any additional supplies required. It will also provide information on the specific stitches and techniques that will be used throughout the project, ensuring that the reader has a clear understanding of how to execute each step.

The step-by-step instructions will break down the creation process into manageable sections, allowing the reader to follow along easily. Each

step will be accompanied by clear and concise explanations, as well as visual aids such as diagrams or photographs, to further assist the reader in understanding the instructions.

The pattern and instructions will also include tips and tricks to help the reader troubleshoot any potential issues that may arise during the crochet process. This could include suggestions for adjusting tension, fixing mistakes, or modifying the pattern to suit personal preferences.

Additionally, the comprehensive pattern and step-by-step instructions may also provide variations or options for customizing the crochet animals. This could include different color schemes, sizes, or even the addition of accessories or embellishments.

Overall, the output of the comprehensive pattern and step-by-step instructions for animal crochet will provide the reader with all the necessary information and guidance to successfully create their own crochet animals. It will be a valuable resource for both beginners and experienced crocheters, allowing them to explore their creativity and create adorable and unique crochet animals.

Styling and Enjoying Your Cat Beanie of Animal Crochet:

If you're a cat lover and enjoy all things crochet, then you're in for a treat with the cat beanie of animal crochet. This adorable accessory not only keeps you warm during the colder months but also adds a touch of feline charm to your outfit. In this guide, we'll explore different ways to style and enjoy your cat beanie, making it a versatile and fun addition to your wardrobe.

First and foremost, let's talk about the design of the cat beanie. Made from soft and cozy yarn, this beanie features cute cat ears and a face, giving it a playful and whimsical look. The attention to detail in the crochet work is impressive, making it a true work of art. Whether you're a beginner or an experienced crocheter, you'll appreciate the craftsmanship that goes into creating this unique accessory.

Now, let's dive into the various ways you can style your cat beanie. One of the simplest and most popular options is to pair it with a casual outfit. Throw on your favorite jeans, a cozy sweater, and slip on your cat beanie for an instant touch of cuteness. This look is perfect for running errands, grabbing coffee with friends, or simply lounging around at home. The beanie adds a playful element to your ensemble, making it a conversation starter wherever you go.

If you're feeling a bit more adventurous, you can also incorporate your cat beanie into a more dressed-up look. Pair it with a little black dress, tights, and ankle boots for a chic and unexpected twist. The juxtaposition of the beanie's whimsical design with a more sophisticated outfit creates a unique and eye-catching ensemble. This is a great option for a night out or a special occasion where you want to stand out from the crowd.

Aside from styling, there are also various ways to enjoy your cat beanie beyond wearing it. If you're a fan of photography, why not use your beanie as a prop in a cute cat-themed photoshoot? Pose with your furry friend or create a whimsical scene with other cat-themed accessories. The possibilities are endless, and you'll have a blast capturing adorable moments with your cat beanie.

Furthermore, if you're a crafty individual, you can even use your cat beanie as a decorative item. Hang it on a hook in your bedroom or living room to add a touch of charm to your space

Project Overview and Desired Outcome of Animal Crochet: The project overview of Animal Crochet involves creating a variety of crochet patterns inspired by animals. The desired outcome is to provide crochet enthusiasts with a collection of unique and adorable animal-themed patterns that they can use to create their own crochet projects.

The Animal Crochet project aims to cater to both beginners and experienced crocheters by offering a range of patterns with varying levels of difficulty. The patterns will include a diverse selection of animals, such as dogs, cats, birds, farm animals, and even exotic creatures like elephants and giraffes. Each pattern will be carefully designed to capture the essence and characteristics of the animal it represents.

The project will focus on creating detailed and comprehensive patterns that are easy to follow. Each pattern will include step-by-step instructions, accompanied by clear and concise diagrams or images to assist crocheters in visualizing the process. Additionally, the patterns will provide information on the materials required, recommended yarn types, and the appropriate crochet hook sizes.

To ensure the quality and accuracy of the patterns, extensive research will be conducted on the anatomy and features of each animal. This will enable the patterns to accurately depict the unique traits and characteristics of the animals, making the finished crochet projects more realistic and visually appealing.

The desired outcome of Animal Crochet is to inspire creativity and provide a platform for crocheters to express their love for animals through their craft. By offering a wide range of animal patterns, the project aims to cater to different preferences and interests. Whether someone is a dog lover, a fan of marine life, or fascinated by jungle creatures, Animal Crochet will have patterns that resonate with their interests.

In addition to providing patterns, the project also aims to foster a sense of community among crocheters. This will be achieved through the creation of an online platform where crocheters can share their finished projects, seek advice, and connect with fellow animal crochet enthusiasts. The platform will also serve as a hub for updates on new patterns, tutorials, and tips and tricks to enhance crocheting skills.

Overall, the Animal Crochet project seeks to bring joy, creativity, and a sense of accomplishment to crocheters of all skill levels. By providing detailed and realistic animal patterns, the project aims to inspire and enable crocheters to create beautiful and unique animal-themed crochet projects.

Materials Needed and Yarn Suggestions of Animal Crochet: When it comes to animal crochet, there are a few materials that you will need to get started. First and foremost, you will need yarn. The type of yarn you choose will depend on the specific animal you are crocheting and the desired outcome.

For smaller animals, such as amigurumi, it is best to use a lightweight yarn. This will allow you to create intricate details and achieve a more realistic look. A popular choice for amigurumi is acrylic yarn, as it is affordable, easy to work with, and comes in a wide range of colors.

If you are looking to create larger animals or ones with more texture, you may want to consider using a bulkier yarn. This will give your project a more substantial feel and make it stand out. Wool yarn is a great option for larger animals, as it is warm, durable, and has a natural texture that can mimic fur or feathers.

In addition to yarn, you will also need a crochet hook. The size of the hook will depend on the thickness of your yarn and the desired tension of your stitches. It is important to choose a hook that is comfortable for you to hold and allows you to easily manipulate the yarn.

Other materials you may need include stuffing, safety eyes or buttons for the animal's eyes, and a yarn needle for sewing pieces together. These can all be found at your local craft store or online.

When it comes to choosing the right yarn for your animal crochet project, it is important to consider the overall look and feel you are trying to achieve. Experiment with different yarns and hook sizes to find the perfect combination for your specific animal. Remember, the possibilities are endless when it comes to animal crochet, so have fun and let your creativity soar!

tools & materials

Yarn

When it comes to yarn for your toy projects, think quality over quantity. Look for high-quality yarns that will crochet into a smooth and sturdy material. Easy-to-clean and/or washing-machine-safe cottons, blended fibers, and acrylic yarns are ideal for making toys. 150–175 yards of your cat's main color and 50–70 yards of the secondary colors should be enough to cover each pattern.

Stuffing

Available in most craft stores, polyester fiberfill stuffing will maintain its loft over time and is easy to clean and care for.

Hooks

Crochet hooks come in a variety of materials, sizes, and handle styles. It's ideal if you can try a hook or two out before purchasing a set. For the most accurate sizing, refer to the millimeter measurements when selecting a hook for your project.

The projects in this book can be made with either a G/6 4mm or F/5 3.75mm hook (whichever gives you a tighter stitch for your yarn). If you find that your stitches are still not tight enough, or the stuffing shows though your work, try going down one or two more hook sizes.

Scissors

A good pair of scissors will make for clean cuts and quick snips.

Tapestry Needle

A quality metal tapestry needle will make sewing your work together a snap! Avoid plastic needles as they sometimes bend when going through multiple layers of crochet.

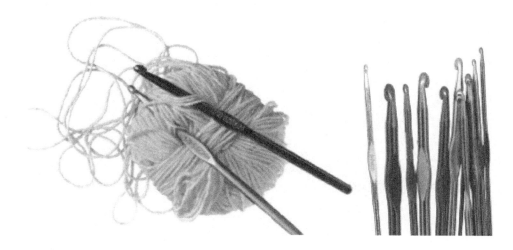

Safety Eyes & Noses

Safety eyes and noses are attached using a plastic washer and are great for toys intended for children ages three and older. For children younger than three years of age, noses can be embroidered (pg 18) and eyes can be applied in tight groupings of satin stitches or as a pair of French knots.

Notions and Storage

Here is a list of a few more goodies to add to your crochet supplies!

Stitch Counter: A row or stitch counter will help you keep track of where you are in your pattern.

Marking Pins: Super handy for helping to position your pattern pieces before sewing everything together.

Split or Locking Rings: While some patterns will specifically call for "place markers" (abbreviation: "pm") to help mark useful landmarks on your work, these rings can also help you track where your rounds begin, mark the corners of a square piece, or hold two edges of your work together for easier sewing.

Automatic Pencil and Sticky Notes:
Great for jotting down notes and sticking them into your book as you work.

Project Bags: A small project bag (like a pencil case) is great for storing smaller tools and notions while a larger bag can hold everything you need for your current project. I find that reusable canvas shopping bags make great project bags!

crochet stitches

THIS SECTION WILL PROVIDE A complete overview of the stitches used in all ten projects.

Where relevant, abbreviations used in the crochet instructions can be found here. For a complete list, see pg 79.

Slipknot

1. Make a loop with a 6" tail. Overlap the loop on top of the yarn coming out of the skein.

1. SLIPKNOT

2. Insert your hook into the loop and under the yarn. Pull to tighten the loop around the hook.

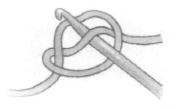

2. SLIPKNOT

Yarn Over (YO)

Wrap the yarn over your hook from back to front.

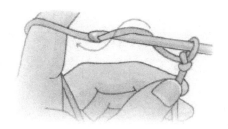

YARN OVER

Chain (ch)

1. Make a slipknot on your hook.

2. Yarn over (YO) and draw the yarn through the loop on your hook. You will have one loop on your hook and a slipknot below it.

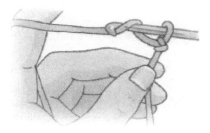

1 & 2. CHAIN

3. Repeat step 2 until you have made the number of chain stitches specified in the pattern. When counting chains, only count the chains below the loop on the hook.

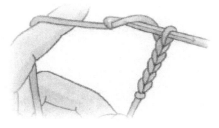

3. CHAIN

Slip Stitch (sl st)

Insert your hook into the next chain or stitch, YO and draw the yarn through the stitch and the loop on your hook while keeping your tension as loose as possible.

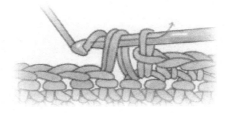

SLIP STITCH

Single Crochet (sc)

1. Insert your hook into the next chain or stitch and YO. Draw the yarn through the chain or stitch. You will have two loops on your hook.

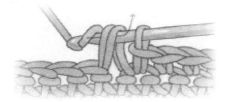

1. SINGLE CROCHET

2. YO and draw the yarn through both loops on your hook to complete the single crochet.

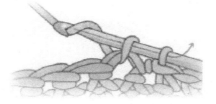

2. SINGLE CROCHET

Half-Double Crochet (hdc)

1. YO and insert your hook into the next chain or stitch. YO a second time and draw the yarn through the chain or stitch. You will have three loops on your hook.

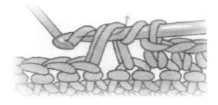

1. HALF-DOUBLE CROCHET

2. YO and draw the yarn through all three loops on your hook to complete the half-double crochet.

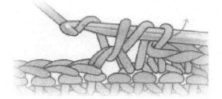

2. HALF-DOUBLE CROCHET

Double Crochet (dc)

1. YO and insert your hook into the next chain or stitch. YO a second time and draw the yarn through the chain or stitch. You will have three loops on your hook.

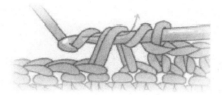

1. DOUBLE CROCHET

2. YO and draw the yarn through just the first two loops on your hook. You will have two loops remaining on your hook.

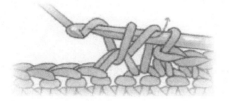

2. DOUBLE CROCHET

3. YO and draw the yarn through the last two loops on your hook to complete the double crochet.

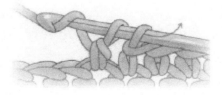

3. DOUBLE CROCHET

Increases (sc 2 in next st)

Work two or more stitches into the same stitch when indicated.

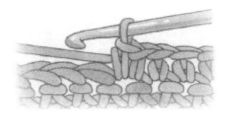

INCREASES

Decreases

Patterns in this book use a variety of decrease options, such as crocheting two stitches together and/or skipping stitches entirely.

Single-Crochet Decrease (sc2tog)

1. Insert your hook into the next stitch, yarn over the hook, and pull through the stitch, leaving a loop on your hook. You'll have two loops on your hook.

2. Repeat step 1 in the next stitch. You'll have three loops on your hook.

3. Yarn over the hook and pull through all three loops. You'll have one loop on your hook.

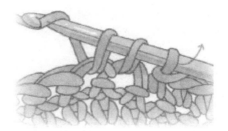

SINGLE-CROCHET DECREASE

The Invisible Decrease

This technique helps reduce the gap that sometimes occurs when making a traditional single-crochet decrease.

1. Insert your hook into the front loop of the next stitch and then immediately into the front loop of the following stitch. You'll have three loops on your hook.

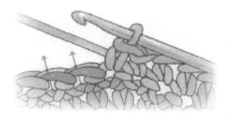

1. INVISIBLE DECREASE

2. Yarn over and draw the working yarn through the two front loops on the hook. You'll have two loops on your hook.

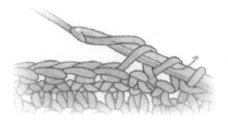

2. INVISIBLE DECREASE

3. Yarn over the hook and pull through both loops on your hook to complete the stitch. You'll have one loop on your hook.

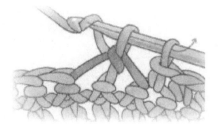

3. INVISIBLE DECREASE

Skip (sk)

Per the pattern instructions, count and skip the number of stitches indicated before working the next stitch in the pattern.

Working in Back Loops (bl), Front Loops (fl), and Both Loops (tbl)

Work in both loops of a stitch except when the pattern instructs that a stitch should be worked in the back loop or front loop. The front loop is the loop closest to you. The back loop is behind the front loop. If a round or row begins with "In bl" or "In fl," work the entire rnd/row in that manner unless you are instructed to switch.

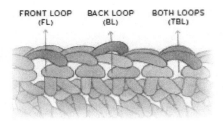

WORKING IN BACK LOOPS, FRONT LOOPS, AND BOTH LOOPS

crochet techniques

Working in Rows

For pattern pieces that are worked in rows, there will be a "turning" chain at the beginning of each new row. Skip over this when beginning to work that row.

Working in the Round

Many patterns in this book are worked in a spiral in which there is no slip stitch or chains between rounds (rnds). When you reach the end of the round, simply continue crocheting in to the next round. To help keep track of where your rounds begin and end, place a stitch marker in the last stitch of your round.

Adjustable Ring (AR)

The adjustable ring (AR) is a great technique that will minimize the hole in the middle of your starting round.

1. Form a ring with your yarn, leaving a 6" tail. Insert the hook into the loop as if you were making a slipknot.

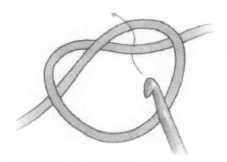

1. ADJUSTABLE RING

2. YO the hook and draw the yarn through the loop as if to make a slip stitch, but do not tighten the loop.

2. ADJUSTABLE RING

3. Ch 1 and then sc over both strands of yarn that make up the edge of the adjustable ring until you've reached the number of stitches indicated in the pattern. To close the center of the ring, pull firmly on the yarn tail.

To start your next round, work your next stitch in the first single crochet of the completed adjustable ring. For patterns that require a semicircle base shape, you will be asked to ch 1 and turn your work so that the back of the piece faces you before working the next row in your pattern.

3. ADJUSTABLE RING

Right Side (RS) / Wrong Side (WS)

When working in the round, the side of your pattern perceived as the right side (RS) will affect which part of the stitch is the "back loop" versus the "front loop." The 6" tail left over from forming the adjustable ring will usually lie on the wrong side (WS), or back of your work. The same can be said for patterns that begin by working around a chain, provided you hold the 6" yarn tail at the back of your work as you crochet the first rnd.

Changing Colors

Work the stitch before the color change up until you reach the last step, in which you would draw the yarn through the remaining loop(s) on your hook to complete the stitch.

To change colors, YO the hook with your new color and draw the new color through the remaining loop(s) on your hook, completing the stitch. You can then

continue on to the next stitch in the new color.

For color changes at the beginning of a row, complete the stitch in your previous row, then introduce the new color when you make your single turning chain. Turn your work, skip the turning chain, and continue to work with your new color for the next row.

For turning chains with two or more stitches, change your color in the last chain before you turn.

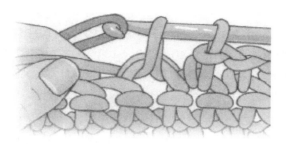

Straighter Seams in the Round

When working in the round, there is a tendency for stitches to offset slightly as they spiral from one round to the next. To help keep your pattern from "twisting" while working in the round, try adding a small joining chain.

1. Working in the first stitch of the new round, sl st and pull tightly, ch 1, and pull tightly to create a joining ch.

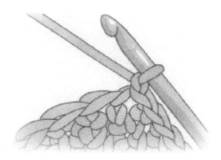

1. STRAIGHT SEAM

2. Continue working in the same stitch of the new round and make your first stitch as written. Pm if desired to help mark where your round begins.

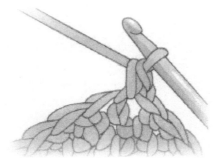

2. STRAIGHT SEAM

This small joining chain will help create a straighter seam as you work. If your seam is still slanting, try tightening your sl st and ch 1 some more. Take care not to work in the joining ch as you work from one round to the next.

Jogless Color Change

When working color changes in the round, the colors will sometimes appear to "break" or "jog" into a step-like pattern from one round to the next. To help reduce the color jog, use the following stitch combination to blend the beginning and end of your color changes.

1. Complete the last stitch of your round in your first color. Sl st in front loop of first st of next round and pull tight.

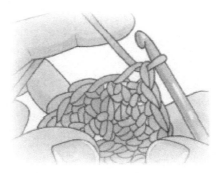

1. JOGLESS COLOR CHANGE

2. Working in the same stitch, pick up your new color, sl st in back loop of stitch, pull yarn tight, ch 1, and pull yarn tight.

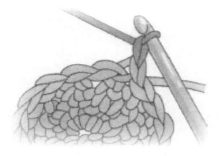

2. JOGLESS COLOR CHANGE

3. Working in the next st, complete your first stitch as written. Pm if desired to help mark where your round begins, as you will skip over the two slip stitches and ch 1 when you begin the next round.

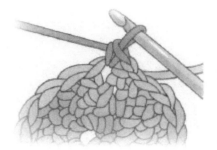

3. JOGLESS COLOR CHANGE

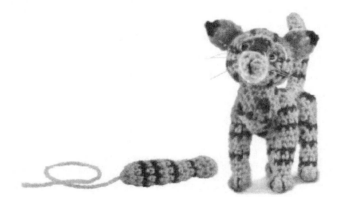

finishing stitches

ONCE YOUR PATTERN PIECES are ready, you can assemble and embellish your cats with just a handful of basic stitches. Before you begin, look over the photos for each cat. Use marking pins to help work out the placement of all the pattern pieces before sewing everything together.

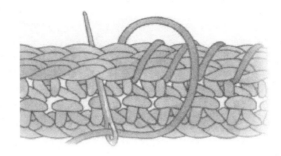

Whip Stitch

Use this stitch to close flat seams. Using your tapestry needle and yarn, draw your needle and yarn through your work and catch the edge(s) of the second piece you wish to sew in place. Pull the yarn through the edge(s) before drawing the yarn through your work again in a spirallike motion. Continue until the seam is closed or the piece is attached.

Mattress Stitch

The mattress stitch provides a nice tight seam when sewing crochet surfaces together.

Choose a point on the surface or edge of your first piece. Insert the needle from A to B under a single stitch, and pull the yarn through. Cross over to the opposite surface and draw your needle under a single stitch from C to D with the entry point at C lining up between points A and B on the first surface. Return to the first surface and insert the needle directly next to (or above, if you're working vertically) exit point B. Continue to work back and forth in this manner until the seam is closed, pulling firmly after every few stitches to ensure a clean closed seam.

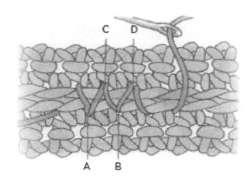

Closing Round Holes

To close round holes, start by threading the remaining yarn tail onto a tapestry needle. Following the edge of the round opening, insert the needle through just the front loops (unless otherwise indicated) of each stitch, effectively winding the tail around the stitches. When you've worked all the way around the opening, pull the tail firmly to close the hole (just like you were cinching a drawstring bag closed).

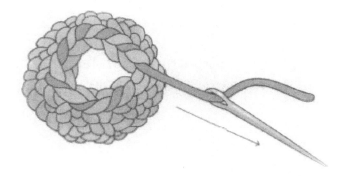

Running Stitch

Use this stitch to attach felt pieces or flattened crochet pieces to your work. With thread and a sewing needle, draw your thread in and out of the surface of your piece in a dashed-line pattern.

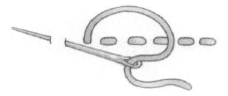

tip
Leave long yarn tails when you fasten off the last rounds of your pieces to help with assembly! Begin by using straight pins to "dry

41

fit" your pieces together to ensure everything is
even and balanced. Then, using the leftover
yarn tails, work a stitch at the base of each
straight pin to tack your pieces in place.
Remove the pins and finish sewing your pieces
down using a whip or mattress stitch.

Back Stitch

Use this stitch to create line details on the surface of your piece. Begin by
drawing the yarn up through the surface of your piece at A and then reinserting
the needle at B. Next, draw your yarn up at C and then reinsert the needle at A.
Continue to work in this manner to create a solid line of stitches.

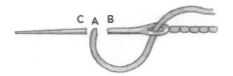

Satin Stitch

Apply satin stitches by grouping short- or medium-length stitches closely
together to build up a shape or fill an area with color.

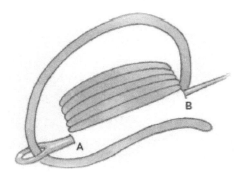

Fringe Knot

1. To create a fringe knot, insert your hook through a stitch loop or space along
the surface of your work, fold a piece of yarn over the hook and draw the yarn
through to create a loop on your hook.

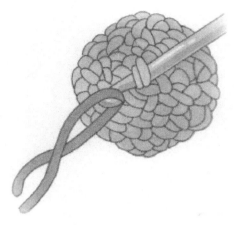

1. FRINGE KNOT

2. Draw the yarn tails through this loop and pull tightly to secure it.

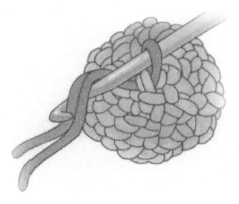

2. FRINGE KNOT

If you wish to create a fringe knot with multiple strands of yarn (like for a thick and fluffy Persian coat), use a larger hook to help keep the strands together as you draw them through your work. Once you are happy with the placement of your fringe knots, use your tapestry needle to tease the yarn plies apart.

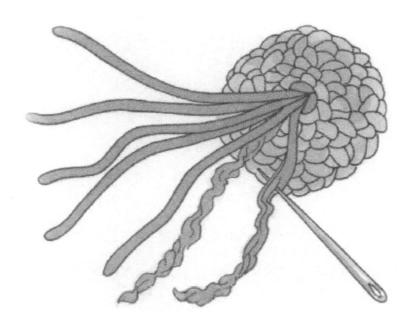

Float vs. Cut

When switching back and forth between colors while working in the round, it can be easier to maintain your piece's shape if you cut and rejoin yarn for color changes instead of floating the yarn behind your work. And, since all the yarn ends will be on the inside of your work, you won't have to weave in any of the yarn ends.

Embroidered Nose

If you would like to embroider your kitty's nose or are gifting your toy to a child who is younger than three years of age, it's best to wait until your cat's head is put together so you can get the best fit for your cat's muzzle.

1. To create the nose, begin by taking pink yarn and drawing a few horizontal long stitches across the front of the muzzle.

1. EMBROIDERED NOSE

2. Once you are happy with the placement, gently wind the pink yarn around the grouping of long stitches to enclose them, and to build up the nose shape.

2. EMBROIDERED NOSE

3. Add a grouping of 3–5 stitches vertically over the front of the nose to create the middle shape. Apply a small, short vertical stitch to the ends of the nose to define the nostrils.

3. EMBROIDERED NOSE

Lip Cleft

If you have embroidered the nose, thread black yarn onto a tapestry needle, insert the needle through the top of the muzzle, behind the nose, and draw the yarn out at the base of the nose, leaving a 6" tail at the starting point. Continue as instructed from the asterisk in step 2.

If you have installed a plastic nose (for kids three years of age and up), you may find the safety nose backing gets in the way when trying to embroider the lip cleft detail. Here's an easier approach to adding the lip line.

1. Take a 12" piece of black yarn, split the yarn plies in half (so a 4-ply yarn strand would become 2 ply), and tie it around the post of the nose, leaving two 6" yarn tails sticking out at the front of the nose.

1. LIP CLEFT

2. Thread the yarn tails onto your tapestry needle. *Draw a long stitch down over the front of the muzzle and reinsert the needle behind the muzzle shaping. Bring the yarn tails up through the top of the muzzle. If you are working with an embroidered nose, bring the yarn up through the muzzle at your starting point. Pull the yarn to cinch the lip cleft and shape the two sides of the muzzle. Knot the yarn tails together and weave the ends back into the head.

2. LIP CLEFT

birman kitten

Legend says that the sweet Birman Kitten, with its striking blue eyes and adorable white "socks," is descended from sacred temple cats. However, if you don't happen to have a temple handy to pay proper tribute, an offering from your dinner plate should work in a pinch.

Materials

F/5 3.75mm Crochet Hook
Worsted-Weight Yarn in White, Rust, and Black
Metal Tapestry Needle Stuffing
(1) Pair of 10mm Cat Safety Eyes
9mm Pink Safety Nose Scissors
Optional: Row Counter, Split/Locking Rings, Pink Felt for Tongue, Off-White Sewing Thread for Whiskers

Yarn Used

White, Rust, and Black Yarn

Additional Options Cascade 220 #8505 White, #2414 Ginger, #8555 Black

Finished Size

3.5" tall, 2.5" long

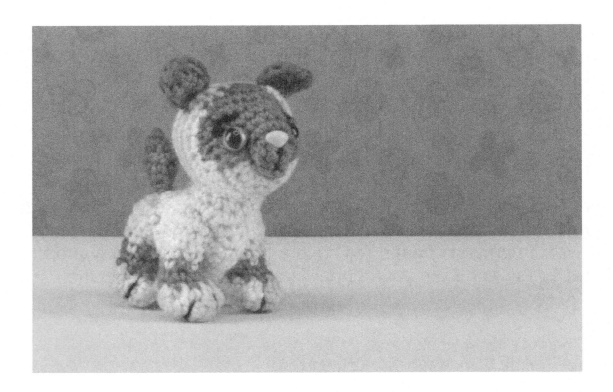

tip

Check out tips and tricks for embroidered noses and muzzle shaping on **pgs 18–19**. Refer to "Changing Colors" for cleaner color changes and "Straighter Seams in the Round" on **pgs 11–12** to help keep your cat's head markings from twisting as you work!

With rust, make a 4-st AR.

Rnd 1: Hdc 2 in next st*, sc 2 in next 2 sts, hdc 2 in next st*. (8 sts)

Rnd 2: Hdc 2 in next 2 sts, sc 4, hdc 2 in next 2 sts. (12 sts)

Rnd 3: Sc2tog 2 times, sc 2 in next 4 sts, sc2tog 2 times. (12 sts)

Rnd 4: In white, hdc 2 in next 2 sts; in rust, sc 2 in next 2 sts, sc 4, sc 2 in next 2 sts; in white, hdc 2 in next 2 sts. (20 sts)

Rnd 5: Sc 4; in rust, hdc 4, sc 4, hdc 4; in white, sc 4. (20 sts)

Rnd 6: Hdc 5; in rust, hdc 2 in next 2 sts, sc 2 in next 2 sts, sc 2, sc 2 in next 2 sts, hdc 2 in next 2 sts; in white, hdc 5. (28 sts)

Rnd 7: Sc 7, sc 2 in next 2 sts, sc 1; in rust, sc 8; in white, sc 1, sc 2 in next 2 sts, sc 7. (32 sts)

Rnd 8: Sc 14; in rust, sc 4; in white, sc 14. (32 sts)

Rnd 9: Sc 15; in rust, sc 2; in white, sc 15. (32 sts)

Rnds 10–11: Sc 32.

Rnd 12: (Sc 2, sc2tog) 8 times. (24 sts)

Rnd 13: (Sc 1, sc2tog) 8 times. (16 sts)

Rnd 14: (Sc 2, sc2tog) 4 times. (12 sts)

Fasten off yarn, leaving a long tail for sewing.

**The "hdc 2s" at the beginning and end of Rnd 1 will become the lower front edge of the muzzle shaping. The seam will run along the underside of the head.*

Stuff muzzle and head. If embroidering the nose, see pg 18. If using a 9mm plastic safety nose, attach nose to the front of the muzzle, one rnd above the 4-st AR, with the muzzle shaping pointing down. Position 10mm safety eyes on the sides of the head behind the muzzle.

Remove stuffing, attach the safety eye and nose backings, and then restuff head. Close hole in the back of the head. With black yarn, add a lip cleft to the muzzle, below the nose (pg 19). With black yarn, embroider eyebrows.

With rust-colored yarn and tapestry needle, draw an 8" piece of yarn back and forth through the head in front of the eyes, pulling gently to sink the eyes into the head. When you are happy with the head shaping, secure the yarn and sew in the ends.

Optional: If you would like to add whiskers, cut three 6" pieces of off-white thread and attach under the muzzle using fringe knots. Using a sewing needle or crochet hook, draw the yarn out through the sides of the muzzle.

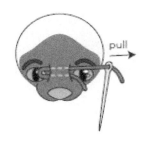

MOUTH

With rust, make a 4-st AR. Do not join.

Fasten off yarn, leaving an 8" tail for sewing.

Sew the flat edge of the mouth behind the muzzle shaping.

Optional: Glue or sew in a small pink tongue made of felt.

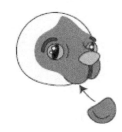

EAR (MAKE TWO)

With rust, loosely ch 4.

Row 1: Starting in second ch from hook, sc 3. Turn. (3 sts)

Row 2: Ch 1, sc 1, sk 1, sc 1. Turn. (2 sts)

Row 3: Ch 1, sc2tog, and pm. (1 st)

Continue to sc around the entire edge of the ear until you reach the pm st from Row 3. (Sc 1, ch 2, sl st 1) in pm st. Fasten off yarn in next st, leaving an 8" tail for sewing.

Pin the flat edges of the ears about 4–5 rounds behind the eyes at a slight angle, allowing the points of the ears to stick up. Position both ears before sewing in place to ensure they are attached evenly. Attach with a whip stitch and weave in the ends.

tip

This pattern also works well in a single color if you'd like to keep things simple!

BODY

With white, make a 4-st AR. Do not join. Turn. You will be working a semicircle shape.

Row 1: Ch 1, sc 2 in each st across. Turn. (8 sts)

Row 2: Ch 1, (sc 1, sc 2 in next st) 2 times, (sc 2 in next st, sc 1) 2 times. Turn. (12 sts)

Rows 3–5: Ch 1, sc 12. Turn. (12 sts)

Row 6: Ch 1, sc 2 in next 2 sts, sc across until 2 sts remain, sc 2 in next 2 sts. Turn. (16 sts)

Row 7: Ch 1, sc 2 in next 2 sts, sc across until 2 sts remain, sc 2 in next 2 sts. Do not turn. (20 sts)

Hold the ends of Row 7 together to create the neck opening. Work your next stitch across the gap to begin Rnd 8, and continue working the rest of the pattern in the round.

Rnds 8–9: Sc 20.

Rnd 10: (Sc 2, sc2tog) 5 times. (15 sts)

Rnd 11: (Sc 1, sc2tog) 5 times. (10 sts)

Rnd 12: Sc2tog 5 times. (5 sts)

Fasten off yarn, close hole, and weave in the end.

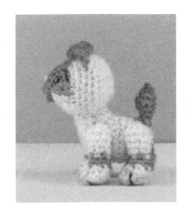

NECK

Rnd 1: Starting at the back of the neck opening, (sl st 1, ch 1, sc 1) to rejoin the white yarn (counts as first sc st), and then sc 15 stitches evenly in a clockwise direction around the entire edge of the neck opening. (16 sts)

Rnd 2: (Sc 2, sc2tog) 4 times. (12 sts)

Rnd 3: Sc 12.

Fasten off yarn, leaving an 8" tail for sewing.

Stuff the body and neck. Starting at the back of the head and using the mattress stitch, sew the open edge of the neck to the back, lower sides, and bottom of the head behind the chin. If you have marking or straight pins, use them to help position the head before you sew.

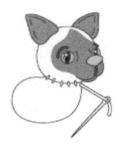

LEG (MAKE FOUR)

With white, make a 6-st AR.

Rnd 1: Sc 2 in each st around. (12 sts)

Rnd 2: Sc 3, hdc 6*, sc 3. (12 sts)

Change to rust.

Rnd 3: Sc 2, sc2tog 4 times, sc 2. (8 sts)

Rnd 4: Sc 8.

Rnd 5: (In rust, sc 1; in white, sc 1) 4 times. (8 sts)

Cut rust. Cont in white.

Rnds 6–7: Sc 8.

Rnd 8: (Sc 3, sc 2 in next st) 2 times. (10 sts)

Rnd 9: Sc 10.

Fasten off yarn, stuff leg, and close hole, leaving an 8" tail for sewing.

The "hdc 6" from Rnd 2 will become the front of the paw.

With black yarn and tapestry needle, draw the yarn from the bottom of the paw up through the top of the paw. Loop over the front edge of the paw and back to the starting point. Loop around one more time and cinch tightly. Repeat the whole process one more time to form the toes. Repeat on all legs. Weave in the ends.

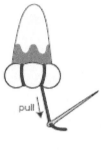

foot bottom

To attach the front legs, line up the tops of the legs with Rnd 1 of the neck, taking care to keep the paws facing forward. Using a mattress stitch, sew the side edges of the upper part of the legs to the sides of the body. Line up the tops of the back legs with the front legs and attach the back legs to the back half of the body in the same manner as the front legs.

To keep the legs from splaying, attach white yarn to the inside surface of one front leg, pass yarn through the body to the inside surface of the opposite front leg, and then back again through the body to the starting point. Pull to draw the legs close to the body, tie off the yarn, and weave in the end. Repeat on the back legs.

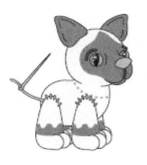

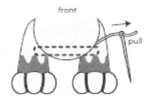

front pull

TAIL

With rust, make a 4-st AR.

Rnd 1: Sc 4.

Rnd 2: (Sc 1, sc 2 in next st) 2 times. (6 sts)

Rnds 3–5: Sc 6.

Lightly stuff the tail. Use the back of the crochet hook if needed.

Rnd 6: Sc2tog 3 times. (3 sts)

Fasten off yarn, leaving a long tail for sewing.

Sew Rnd 1 of the tail to the back of the body.

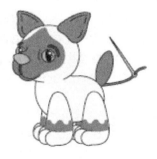

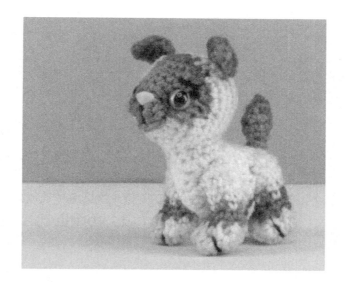

orange tabby kitten

This Orange Tabby Kitten has mischief written all over his adorable little face. He just wants a little playtime with the family hamster. What could go wrong?

Materials

F/5 3.75mm Crochet Hook
Worsted-Weight Yarn in White, Rust, Orange, and Black
Metal Tapestry Needle Stuffing
(1) Pair of 10mm Cat Safety Eyes 9mm Pink Safety Nose Scissors
Optional: Row Counter, Split/Locking Rings, Pink Felt for Tongue, Off-White Sewing Thread for Whiskers

Yarn Used

White, Rust, Orange, and Black

Additional Options Cascade 220 #8505 White, #2414 Ginger, #8555 Black, #7826 California Poppy

Finished Size

3.25" tall, 2.5" long

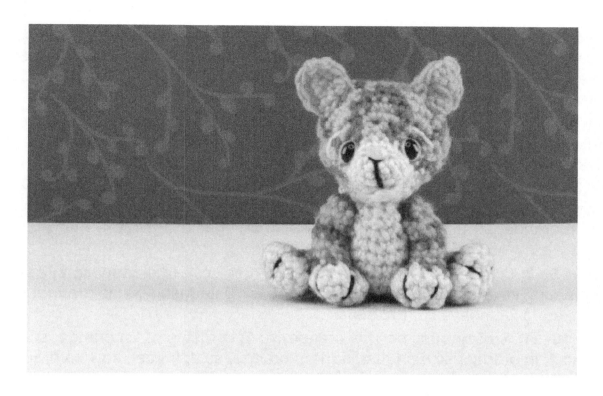

tip

Check out tips and tricks for embroidered noses and muzzle shaping on **pgs 18–19**. Refer to "Changing Colors" for cleaner color changes and "Straighter Seams in the Round" on **pgs 11–12** to help keep your cat's head markings from twisting as you work!

HEAD

With white, make a 4-st AR.

Rnd 1: Hdc 2 in next st*, sc 2 in next 2 sts, hdc 2 in next st*. (8 sts)

Rnd 2: Hdc 2 in next 2 sts, sc 4, hdc 2 in next 2 sts. (12 sts)

Rnd 3: Sc2tog 2 times, sc 2 in next 4 sts, sc2tog 2 times. (12 sts)

Rnd 4: In white, hdc 2 in next 2 sts; (in rust, sc 1; in orange, sc 1) in next 2 sts; in rust, sc 1; in orange, sc 2; in rust, sc 1; (in orange, sc 1; in rust, sc 1) in next 2 sts; in white, hdc 2 in next 2 sts. (20 sts)

Rnd 5: In white, sc 2; in orange, sc 2; (in rust, sc 1; in orange, sc 1) 2 times; in rust, hdc 1; in orange, hdc 2; in rust, hdc 1; (in orange, sc 1; in rust, sc 1) 2 times; in orange, sc 2; in white, sc 2. (20 sts)

Cut white.

Rnd 6: In orange, hdc 4; in rust, hdc 1; in orange, hdc 2 in next st; in rust, sc 1; in orange, sc 2 in next st; in rust, sc 1; in orange, sc 2 in next 2 sts; in rust, sc 1; in orange, sc 2 in next st; in rust, sc 1; in orange, hdc 2 in next st; in rust, hdc 1; in orange, hdc 4. (26 sts)

Rnd 7: Sc 3, sc 2 in next st; (in rust, sc 1; in orange, sc 2 in next 2 sts) 2 times; in rust, sc 2; in orange, sc 2; in rust, sc 2; (in orange, sc 1; in rust, sc 2 in next 2 sts) 2 times; in orange, sc 2 in next st, sc 3. (36 sts)

Rnd 8: Sc2tog 2 times, sc 1; (in rust, sc 1; in orange, sc 1; in rust, sc 1; in orange, sc 2) 2 times, sc 1; in rust, sc 4; in orange, sc 1, (in orange, sc 2; in rust, sc 1; in orange, sc 1; in rust, sc 1) 2 times; in orange, sc 1, sc2tog 2 times. (32 sts)

Rnd 9: Sc 3; (in rust, sc 1; in orange, sc 1; in rust, sc 1; in orange, sc 2) 2 times, sc 2; in rust, sc 2; in orange, sc 2, (in orange, sc 2; in rust, sc 1; in orange, sc 1; in rust, sc 1) 2 times; sc 3. (32 sts)

Rnds 10–11: Sc 5; in rust, sc 1; in orange, sc 4; in rust, sc 1; in orange, sc 2; in rust, sc 1; in orange, sc 4; in rust, sc 1; in orange, sc 2; in rust, sc 1; in orange, sc 4; in rust, sc 1; in orange, sc 5. (32 sts)

Cut rust.

Rnd 12: (Sc 2, sc2tog) 8 times. (24 sts)

Rnd 13: (Sc 1, sc2tog) 8 times. (16 sts)

Rnd 14: (Sc 2, sc2tog) 4 times. (12 sts)

Fasten off yarn, leaving a long tail for sewing.

The "hdc 2s" at the beginning and end of Rnd 1 will become the lower front edge of the muzzle shaping. The seam will run along the underside of the head.

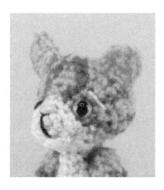

tip
This pattern also works well in a single color if you'd like to keep things simple!

Stuff the muzzle and head. If embroidering the nose, see pg 18. If using a 9mm plastic safety nose, attach nose to the front of the muzzle, one rnd above the 4-st AR, with the muzzle shaping pointing down. Position 10mm safety eyes on the sides of the head behind the muzzle.

Remove stuffing, attach the safety eyes and nose backings, and then restuff head. Close hole in the back of the head. With black yarn, add a lip cleft to the muzzle, below the nose (pg 19). With white yarn, embroider eyebrows.

With rust-colored yarn and tapestry needle, draw an 8" piece of yarn back and forth through the head in front of the eyes, pulling gently to sink the eyes into the head. When you are happy with the head shaping, secure the yarn and sew in the ends.

Optional: If you would like to add whiskers, cut three 6" pieces of off-white thread and attach under the muzzle using fringe knots. Using a sewing needle or crochet hook, draw the yarn out through the sides of the muzzle.

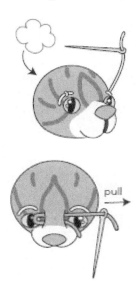

MOUTH

With white, make a 4-st AR. Do not join.

Fasten off yarn, leaving an 8" tail for sewing.

Sew the flat edge of the mouth behind the muzzle shaping.

Optional: Glue or sew in a small pink tongue made of felt.

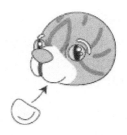

EAR (MAKE TWO)

With orange, loosely ch 4.

Row 1: Starting in second ch from hook, sc 3.

Turn. (3 sts)

Row 2: Ch 1, sc 1, sk 1, sc 1. Turn. (2 sts)

Row 3: Ch 1, sc2tog, and pm. (1 st)

Continue to sc around the entire edge of the ear until you reach the pm st from Row 3. (Sc 1, ch 2, sl st 1) in pm st. Fasten off yarn in next st, leaving an 8" tail for sewing.

Pin the flat edges of the ears about 4–5 rounds behind the eyes at a slight angle, allowing the points of the ears to stick up. Position both ears before sewing them in place to ensure they are evenly attached. Attach with a whip stitch and weave in the ends.

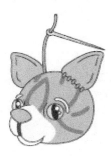

tip
Refer to "Jogless Color Change" on **pg 12** for cleaner color transitions between rounds!

BODY

With orange, make a 5-st AR.

Rnd 1: Sc 2 in each st around. (10 sts)

Rnd 2: (Sc 1, sc 2 in next st) 5 times. (15 sts)

Rnd 3: In white, sc 2, sc 2 in next st; in rust, (sc 2, sc 2 in next st) 3 times; in white, sc 2, sc 2 in next st. (20 sts)

Rnds 4–5: In white, sc 4; in orange, sc 12; in white, sc 4. (20 sts)

Rnd 6: In white, sc 4; in rust, sc 12; in white, sc 4. (20 sts)

Rnd 7: In white, sc 2, sc2tog; in orange, sc 4, sc2tog 2 times, sc 4; in white, sc2tog, sc 2. (16 sts)

Rnd 8: In white, sc 1, sc2tog; in orange, sc 3, sc2tog 2 times, sc 3; in white, sc2tog, sc 1. (12 sts)

Rnd 9: In white, sc 2; in rust, sc 8; in white, sc 2. (12 sts)

Rnd 10: In white, sc2tog; in orange, sc 2, sc2tog 2 times, sc 2; in white, sc2tog. (8 sts)

Rnd 11: In white, sc 1; in orange, sc 6; in white, sc 1. (8 sts)

Fasten off yarn, leaving a long tail for sewing.

Stuff the body and neck. Holding the body vertically, with the white belly facing forward, sew the open edge of the neck to the bottom of the head behind the chin. If you have marking or straight pins, use them to help position the head before you sew.

LEG (MAKE FOUR)

With white, make a 6-st AR.

Rnd 1: Sc 2 in each st around. (12 sts)

Rnd 2: Sc 3, hdc 6*, sc 3. (12 sts)

Change to rust.

Rnd 3: Sc 2, sc2tog 4 times, sc 2. (8 sts)

Change to orange.

Rnds 4–5: Sc 8.

Change to rust.

Rnd 6: Sc 8.

Change to orange.

Rnd 7: Sc 8.

Rnd 8: (Sc 3, sc 2 in next st) 2 times. (10 sts)

Change to rust.

Rnd 9: Sc 10.

Fasten off yarn, stuff leg, and close hole, leaving an 8" tail for sewing.

The "hdc 6" from Rnd 2 will become the front of the paw.

With black yarn and tapestry needle, draw the yarn from the bottom of the paw up through the top of the paw. Loop over the front edge of the paw and back to the starting point. Loop around one more time and cinch tightly. Repeat the whole process one more time to form the toes. Repeat on all legs. Weave in the ends.

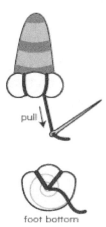

To attach the front legs, line up the tops of the legs on either side of the body, one rnd below the bottom of the head, taking care to keep the paws facing forward. Using a mattress stitch, sew the side edges of the upper part of the legs to the sides of the body. Attach the back legs to the back half of the body so they splay on either side of the front legs.

To keep the legs in place, attach orange yarn to the outside of the back leg (just above the white foot and first rust-colored stripe) and draw the needle through the ankle of the back leg, the ankle of the front leg, the sides of the belly, and through the ankles of the opposite front and back legs. Then, reverse the path of the needle and draw the yarn back through the ankles and belly until you reach your starting point. Pull gently to draw the paws close to each other. Secure the yarn and weave in the ends.

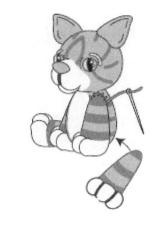

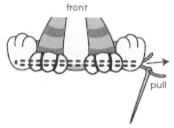

front

pull

TAIL

With orange, make a 4-st AR.

Rnd 1: Sc 4.

Change to rust.

Rnd 2: (Sc 1, sc 2 in next st) 2 times. (6 sts)

Change to orange.

Rnds 3–4: Sc 6.

Change to rust.

Rnd 5: Sc 6.

Lightly stuff the tail. Use the back of the crochet hook if needed. Change to white.

Rnd 6: Sc2tog 3 times. (3 sts)

Fasten off yarn, leaving a long tail for sewing.

Sew the orange end of the tail to the back of the body.

bombay

This lucky black cat is perfectly perched and ready to keep an eye on things. Pair this sweet feline up with a witch's hat around Halloween for a frighteningly adorable look.

Materials

F/5 3.75mm Crochet Hook
Worsted-Weight Yarn in Black and Grey
Metal Tapestry Needle Stuffing
(1) Pair of 10mm Cat Safety Eyes
12mm Pink Safety Nose Scissors
Optional: Row Counter, Split/Locking Rings, Pink Felt for Tongue, Off-White Sewing Thread for Whiskers

Yarn Used

Cascade 220 #8555 Black, #8509 Grey

Finished Size

5" tall, 3" long

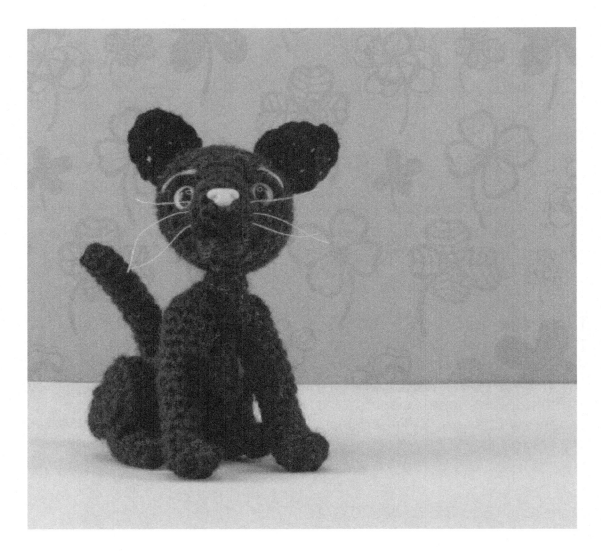

tip
Check out tips and tricks for embroidered noses and muzzle shaping on **pgs 18–19**. Refer to "Straighter Seams in the Round" on **pg 12** to help keep your cat's head shaping from twisting as you work!

HEAD

With black, make a 4-st AR.

Rnd 1: Hdc 2 in next st*, sc 2 in next 2 sts, hdc 2 in next st*. (8 sts)

Rnd 2: Hdc 2 in next 2 sts, sc 4, hdc 2 in next 2 sts. (12 sts)

Rnd 3: Sc2tog 2 times, sc 2 in next 4 sts, sc2tog 2 times. (12 sts)

Rnd 4: Hdc 2 in next 2 sts, sc 2 in next 2 sts, sc 4, sc 2 in next 2 sts, hdc 2 in next 2 sts. (20 sts)

Rnd 5: (Sc 4, sc 2 in next st) 4 times. (24 sts)

Rnd 6: (Sc 2, sc 2 in next st) 8 times. (32 sts)

Rnd 7: Sc 4, hdc 6, sc 12, hdc 6, sc 4. (32 sts)

Rnds 8–10: Sc 32.

Rnd 11: (Sc 2, sc2tog) 8 times. (24 sts)

Rnd 12: (Sc 1, sc2tog) 8 times. (16 sts)

Rnd 13: (Sc 2, sc2tog) 4 times. (12 sts)

Fasten off yarn, leaving a long tail for sewing.

The "hdc 2s" at the beginning and end of Rnd 1 will become the lower front edge of the muzzle shaping. PM in middle of muzzle shaping if desired.

Stuff the muzzle and head. If embroidering the nose, see pg 18. If using a 12mm plastic safety nose, attach nose to the front of the muzzle, one rnd above the 4-st AR, with the muzzle shaping pointing down. Position 10mm safety eyes on the sides of the head behind the muzzle.

Remove stuffing, attach the safety eye and nose backings, and then restuff head. Close hole in the back of the head. With black yarn, add a lip cleft to the muzzle, below the nose (pg 19). With grey yarn, embroider eyebrows.

With black yarn and tapestry needle, draw a 10" piece of yarn back and forth through the head in front of the eyes, pulling gently to sink the eyes into the head. When you are happy with the head shaping, secure the yarn and sew in the ends.

Optional: If you would like to add whiskers, cut three 6" pieces of off-white thread and attach under the muzzle using fringe knots. Using a sewing needle or crochet hook, draw the yarn out through the sides of the muzzle.

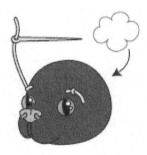

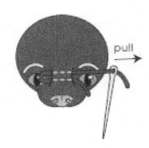

MOUTH

With black, make a 4-st AR. Do not join. Turn. You will be working a semicircle shape.

Row 1: Ch 1, sl st 1, sc 2, sl st 1. (4 sts)

Fasten off yarn, leaving a long tail for sewing.

Sew the flat edge of the mouth behind the muzzle shaping.

Optional: Glue or sew in a small pink tongue made of felt.

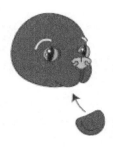

EAR (MAKE TWO)

With black, loosely ch 5.

Row 1: Starting in second ch from hook, sc 4. Turn. (4 sts)

Row 2: Ch 1, sc 1, sc2tog, sc 1. Turn. (3 sts)

Row 3: Ch 1, sc 1, sk 1, sc 1. Turn. (2 sts)

Row 4: Ch 1, sc2tog, and pm. (1 st)

Continue to sc around the entire edge of the ear until you reach the pm st from Row 4. (Sc 1, ch 2, sl st 1) in pm st. Fasten off yarn in next st, leaving an 8" tail for sewing.

Pin the flat edges of the ears about 4–5 rounds behind the eyes at a slight angle, allowing the points of the ears to stick up. Position both ears before sewing them in place to ensure they are evenly attached. Attach with a whip stitch and weave in the ends, sewing from the point of the ears to the base of the ears.

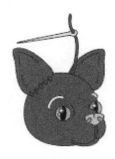

tip

Need some black stuffing? Look for black fiberfill products (like "Halloween Hay") in craft stores around October and stock up!

BODY

With black, make a 6-st AR.

Rnd 1: Sc 2 in each st around. (12 sts)

Rnd 2: (Sc 1, sc 2 in next st) 6 times. (18 sts)

Rnds 3–4: Sc 18.

Rnd 5: (Sc 8, sc 2 in next st) 2 times. (20 sts)

Rnds 6–8: Sc 20.

Rnd 9: (Sc 3, sc2tog) 4 times. (16 sts)

Rnd 10: (Sc 6, sc2tog) 2 times. (14 sts)

Rnd 11: (Sc 5, sc2tog) 2 times. (12 sts)

Rnd 12: Sc 12.

Rnd 13: (Sc 3, sc 2 in next st) 3 times. (15 sts)

Rnd 14: Sc 15.

Rnd 15: (Sc 3, sc2tog) 3 times. (12 sts)

Stuff body.

Rnd 16: (Sc 1, sc2tog) 4 times. (8 sts)

Rnds 17–18: Sc 8.

Fasten off yarn, leaving the neck edge open.

Stuff the body and neck. Holding the body vertically, sew the open edge of the neck to the bottom of the head behind the chin. If you have marking or straight pins, use them to help position the head before you sew.

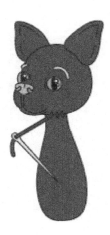

With black, make a 4-st AR.

Rnd 1: Sc 2 in each st around. (8 sts)

Rnd 2: Sc 2, hdc 4*, sc 2. (8 sts)

Rnd 3: Sc 2, sc2tog 2 times, sc 2. (6 sts)

Rnds 4–8: Sc 6.

Rnd 9: (Sc 2, sc 2 in next st) 2 times. (8 sts)

Rnds 10–13: Sc 8.

Rnd 14: (Sc 3, sc 2 in next st) 2 times. (10 sts)

Rnd 15: Sc 10.

Rnd 16: (Sc 3, sc2tog) 2 times. (8 sts)

Fasten off yarn, stuff leg, and close hole, leaving an 8" tail for sewing.

The "hdc 4" from Rnd 2 will become the front of the paw.

Hip:

With black, make an 8-st AR.

Rnd 1: Sc 2 in each st around. (16 sts)

Rnd 2: (Sc 1, sc 2 in next st) 8 times. (24 sts)

Rnd 3: Sc 2, ch 4, sk 4, (sc 1, sc2tog) 6 times. (18 sts)

Rnd 4: Sc2tog, sc 2 in ch-4 sp, sc2tog 6 times. (9 sts)

Fasten off yarn.

Leg:

Rnd 1: With black, (sl st, ch 1 and sc 1) to rejoin yarn anywhere along the edge of the ch-4 opening (counts as first sc st). Sc 7 more stitches evenly around the entire edge of the ch-4 sp. (8 sts)

Rnd 2: (Sc 2, sc2tog) 2 times. (6 sts)

Rnds 3–6: Sc 6.

Rnd 7: (Sc 2, sc 2 in next st) 2 times. (8 sts)

Rnd 8: (Sc 3, sc 2 in next st) 2 times. (10 sts)

Rnd 9: Sc2tog 5 times. (5 sts)

Fasten off yarn, close hole, and weave in the end.

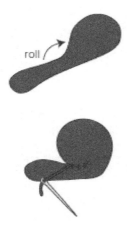

Stuff the leg and hip. Close the hole in the side of the hip. Roll the leg up toward the side edge of the hip. Sew the top side of the leg to the side of the hip with a few stitches to hold it in place. Repeat process on the other leg, but with Rnd 1 of the hip positioned on the opposite side.

With black yarn and tapestry needle, draw the yarn from the bottom of the paw up through the top of the paw. Loop over the front edge of the paw and back to the starting point. Loop around one more time and cinch tightly. Repeat the whole process one more time to form the toes. Repeat on all legs. Weave in the ends.

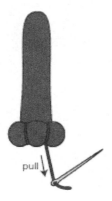

foot bottom

To attach the front legs, line up the tops of the legs on either side of the body, 2–3 rnds below the bottom of the head, taking care to keep the paws facing forward. Using a mattress stitch, sew the side edges of the upper part of the legs to the sides of the body.

Sew the side edges of the hips to the sides of the lower body, keeping the back legs level with the bottom of the body.

To keep the front legs from splaying, attach yarn to the inside surface of one front leg, pass yarn through the chest of the body to the inside surface of the opposite front leg, and then back again through the body to the starting point. Pull to draw the legs close to the body, tie off the yarn, and weave in the end.

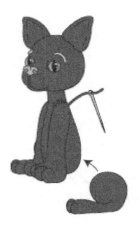

front

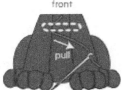

pull

TAIL

With black, make a 6-st AR.

Rnds 1–17: Sc 6.

Rnd 18: (Sc 1, sc 2 in next st) 3 times. (9 sts)

Fasten off yarn, leaving a long tail for sewing.

Lightly stuff the tail. Use the back of the crochet hook if needed. Sew the open edge of the tail to the back of the body.

persian

Fluffy and with an air of refinement, this Persian beauty is just begging to be brushed and styled. Just watch out for the tangles!

Materials

F/5 3.75mm Crochet Hook
Worsted-Weight Yarn in White and Black
Metal Tapestry Needle Stuffing
(1) Pair of 10mm Cat Safety Eyes
12mm Pink Safety Nose Scissors
Optional: Small Slicker Brush, Row Counter, Split/Locking Rings, Pink Felt for Tongue, Off-White Sewing Thread for Whiskers

Yarn Used

Cascade 220 #8505 White, #8555 Black

Finished Size

3.5" tall, 5" long

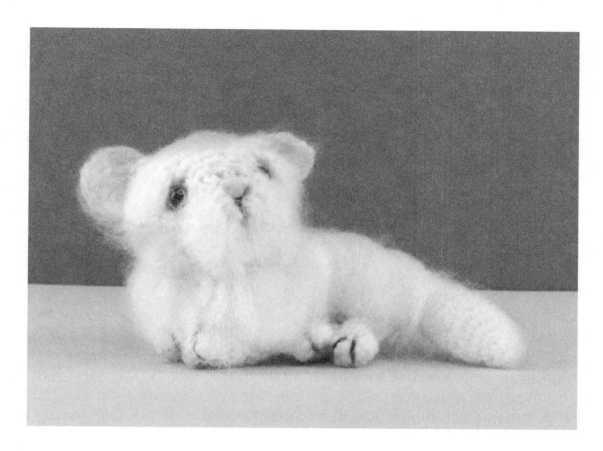

tip

Check out tips and tricks for embroidered noses and muzzle shaping on **pgs 18–19**. Refer to "Straighter Seams in the Round" on **pg 12** to help keep your cat's head shaping from twisting as you work!

HEAD

With white, make an 8-st AR.

Rnd 1: Sc 1, hdc 2 in next 2 sts*, sc 2, hdc 2 in next 2 sts*, sc 1. (12 sts)

Rnd 2: Sc 1, hdc 2 in next 2 sts, sc 6, hdc 2 in next 2 sts*, sc 1. (16 sts)

Rnd 3: Sc 1, sc2tog 2 times, sc 2 in next 6 sts, sc2tog 2 times, sc 1. (18 sts)

Rnd 4: Hdc 2 in next 4 sts, sc 2 in next 2 sts, sc 6, sc 2 in next 2 sts, hdc 2 in next 4 sts. (30 sts)

Rnd 5: Sc 2, hdc 2 in next 4 sts, sc 18, hdc 2 in next 4 sts, sc 2. (38 sts)

Rnd 6: Sc 4, hdc 4, sc 22, hdc 4, sc 4. (38 sts)

Rnd 7: Sc 4, sc2tog 3 times, sc 18, sc2tog 3 times, sc 4. (32 sts)

Rnds 8–10: Sc 32.

Rnd 11: (Sc 2, sc2tog) 8 times. (24 sts)

Rnd 12: (Sc 1, sc2tog) 8 times. (16 sts)

Rnd 13: (Sc 2, sc2tog) 4 times. (12 sts)

Fasten off yarn, leaving a long tail for sewing.

**The "hdc 2s" from Rnds 1 and 2 will become the lower front edge of the muzzle shaping. PM in middle of muzzle shaping if desired.*

Stuff the muzzle and head. If embroidering the nose, see pg 18. If using a 12mm plastic safety nose, attach nose to the front of the muzzle, one rnd above the 8-st AR, with the muzzle shaping pointing down. Position 10mm safety eyes on the sides of the head behind the muzzle.

Remove stuffing, attach the safety eye and nose backings, and then restuff head. Close hole in the back of the head. With black yarn, add a lip cleft to the muzzle, below the nose (pg 19).

With white yarn and tapestry needle, draw a 10" piece of yarn back and forth through the head in front of the eyes, pulling gently to sink the eyes into the head. When you are happy with the head shaping, secure the yarn and sew in the ends.

Optional: If you would like to add whiskers, cut three 6" pieces of off-white thread and attach under the muzzle using fringe knots. Using a sewing needle or crochet hook, draw the yarn out through the sides of the muzzle.

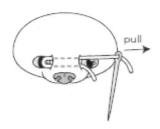

MOUTH

With white, make a 4-st AR. Do not join. Turn. You will be working a semicircle shape.

Row 1: Ch 1, sl st 1, sc 2, sl st 1. (4 sts)

Fasten off yarn, leaving a long tail for sewing.

Sew the flat edge of the mouth behind the muzzle shaping.

Optional: Glue or sew in a small pink tongue made of felt.

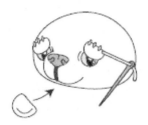

EYELID (MAKE TWO)

With white, make a 4-st AR. Do not join, but pull shaping closed into a semicircle shape.

Fasten off yarn, leaving a long tail for sewing.

Sew flat edge of eyelid above the eye, allowing curved edge to hang over the top of the eye.

EAR (MAKE TWO)

With white, loosely ch 5.

Row 1: Starting in second ch from hook, sc 4. Turn. (4 sts)

Row 2: Ch 1, sc 1, sc2tog, sc 1. Turn. (3 sts)

Row 3: Ch 1, sc 1, sk 1, sc 1. Turn. (2 sts)

Row 4: Ch 1, sc2tog, and pm. (1 st)

Continue to sc around the entire edge of the ear until you reach the pm st from Row 4. (Sc 1, ch 2, sl st 1) in pm st. Fasten off yarn in next st, leaving an 8" tail for sewing.

Pin the flat edges of the ears about 4–6 rounds behind the eyes at a slight angle, allowing the points of the ears to stick up. Position both ears before sewing in place to ensure they are evenly attached. Attach with a whip stitch and weave in the ends.

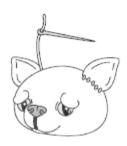

BODY

With white, make a 4-st AR. Do not join. Turn. You will be working a semicircle shape.

Row 1: Ch 1, sc 2 in each st across. Turn. (8 sts)

Row 2: Ch 1, (sc 1, sc 2 in next st) 2 times, (sc 2 in next st, sc 1) 2 times. Turn. (12 sts)

Rows 3–7: Ch 1, sc 12. Turn. (12 sts)

Row 8: Ch 1, sc 2 in next 2 sts, sc across until 2 sts remain, sc 2 in next 2 sts. Turn. (16 sts)

Row 9: Ch 1, sc 2 in next 2 sts, sc across until 2 sts remain, sc 2 in next 2 sts. Do not turn. (20 sts)

Hold the ends of Row 9 together to create the neck opening. Work your next stitch across the gap to begin Rnd 10, and continue working the rest of the pattern in the round.

Rnd 10: Sc 1, sc 2 in next st, sc 4, sc 2 in next st, sc 6, sc 2 in next st, sc 4, sc 2 in next st, sc 1. (24 sts)

Rnds 11–12: Sc 24.

Rnd 13: (Sc 4, sc2tog) 4 times. (20 sts)

Rnds 14–15: Sc 20.

Rnd 16: (Sc 3, sc2tog) 4 times. (16 sts)

Rnds 17–19: Sc 16.

Rnd 20: (Sc 2, sc2tog) 4 times. (12 sts)

Rnd 21: (Sc 4, sc2tog) 2 times. (10 sts)

Rnd 22: (Sc 3, sc2tog) 2 times. (8 sts)

Fasten off yarn, close hole, and weave in the end.

NECK

Rnd 1: Starting at the back of the neck opening, (sl st 1, ch 1, sc 1) to rejoin the white yarn (counts as first sc st), and then sc 17 stitches evenly in a clockwise direction around the entire edge of the neck opening. (18 sts)

Rnd 2: Sc 18.

Rnd 3: (Sc 7, sc2tog) 2 times. (16 sts)

Fasten off yarn, leaving a long tail for sewing.

Stuff the body and neck. Starting at the back of the head and using the mattress stitch, sew the open edge of the neck to the back, lower sides, and bottom of the head behind the chin. If you have marking or straight pins, use them to help position the head before you sew.

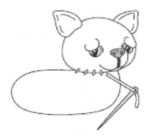

LEG (MAKE FOUR)

Hip/Shoulder:

With white, make an 8-st AR.

Rnd 1: Sc 2 in each st around. (16 sts)

Rnd 2: (Sc 1, sc 2 in next st) 8 times. (24 sts)

Rnd 3: Sc 2, ch 4, sk 4, (sc 1, sc2tog) 6 times. (18 sts)

Rnd 4: Sc2tog, sc 2 in ch-4 sp, sc2tog 6 times. (9 sts)

Fasten off yarn.

Leg:

Rnd 1: With white, (sl st, ch 1, and sc 1) to rejoin yarn anywhere along the edge of the ch-4 opening (counts as first sc st). Sc 7 more stitches evenly around the entire edge of the ch-4 sp. (8 sts)

Rnd 2: (Sc 2, sc2tog) 2 times. (6 sts)

Rnds 3–6: Sc 6.

Rnd 7: (Sc 2, sc 2 in next st) 2 times. (8 sts)

Rnd 8: (Sc 3, sc 2 in next st) 2 times. (10 sts)

Rnd 9: Sc2tog 5 times. (5 sts)

Fasten off yarn, close hole, and weave in the end.

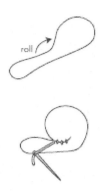

Stuff three legs and close the holes in the side of the hips/shoulders. On the fourth back leg, only stuff the leg, leaving the hip unstuffed before closing the hole. For the three fully-stuffed legs, roll two of the legs up toward the side of the hips/shoulders and apply a few stitches to hold them in place. With the third leg, roll the leg down toward the side of the shoulder so that Rnd 1 of the shoulder is positioned on the opposite side. Leave the partially-unstuffed leg unrolled.

With black yarn and tapestry needle, draw the yarn from the bottom of the paw up through the top of the paw. Loop over the front edge of the paw and back to the starting point. Loop around one more time and cinch tightly. Repeat the whole process one more time to form the toes.

Repeat on all legs. Weave in the ends.

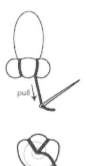

To attach the front legs, position two stuffed legs on the sides of the body, lining up the tops of the shoulders with Rnd 1 of the neck. Using a mattress stitch, sew the side edges of the shoulders to the sides of the body, keeping the legs level with the ground.

Sew the stuffed back hip to the back half of the body in the same manner as the front legs. Flatten out the unstuffed hip and place it on the opposite side of the body, underneath the cat, so that the leg sticks out next to the other back leg. Sew the edges of the unstuffed hip to the body.

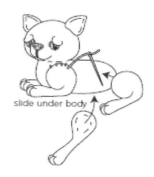

slide under body

TAIL

With white, make a 5-st AR.

Rnds 1–2: Sc 5.

Rnd 3: (Sc 1, sc 2 in next st) 2 times, sc 1. (7 sts)

Rnd 4: Sc 2 in next st, (sc 1, sc 2 in next st) 3 times. (11 sts)

Rnds 5–7: Sc 11.

Rnd 8: Sc 1, (sc 2, sc 2 in next st) 3 times, sc 1. (14 sts)

Rnd 9: Sc 14.

Rnd 10: Sc 12, sc2tog. (13 sts)

Rnd 11: Sc 13.

Rnd 12: Sc 11, sc2tog. (12 sts)

Rnd 13: (Sc 4, sc2tog) 2 times. (10 sts)

Rnd 14: (Sc 3, sc2tog) 2 times. (8 sts)

Stuff tail.

Rnd 15: Sc 8.

Rnd 16: Sc2tog 4 times. (4 sts)

Fasten off yarn, leaving a long tail for sewing.

Attach Rnd 16 of the tail to the back of the body.

To make your Persian extra silky, cut eighteen 10" strands of white yarn and attach them around the neck using a fringe knot. Continue to add more yarn in the same manner, cutting twenty to twenty-four 10" strands and attaching them along the spine in a double line. Cut eight 10" strands and attach around the base of the tail. Cut eight 4" strands and attach them to the front of the muzzle. Use a tapestry needle to separate the yarn plies. Brush out with a slicker brush and style with fingers and scissors.

sphynx

The regal-looking Sphynx sports a peach-fuzz coat that simply begs for warm crochet accessories to help keep him cozy when the weather gets nippy.

Materials

F/5 3.75mm Crochet Hook
Worsted-Weight Yarn in Black, Grey, and Pink
Metal Tapestry Needle Stuffing
(1) Pair of 10mm Cat Safety Eyes
12mm Pink Safety Nose Scissors
Optional: Row Counter, Split/Locking Rings, Pink Felt for Tongue

Yarn Used

Cascade 220 #8555 Black, #8509 Grey, #4192 Soft Pink

Finished Size

4.5" tall, 5" long

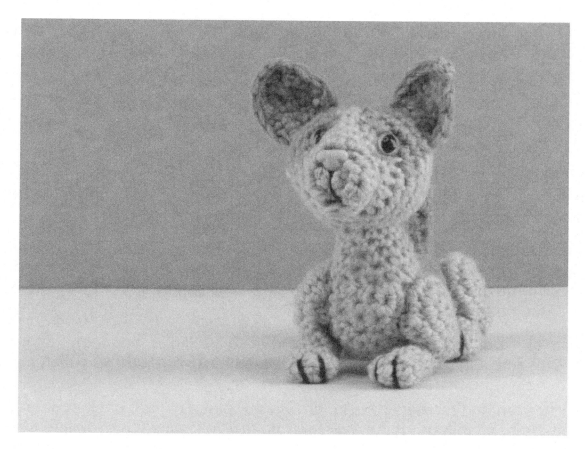

HEAD

With pink, make a 4-st AR.

Rnd 1: Hdc 2 in next st*, sc 2 in next 2 sts, hdc 2 in next st*. (8 sts)

Rnd 2: Hdc 2 in next 2 sts*, sc 4, hdc 2 in next 2 sts*. (12 sts)

Rnd 3: Sc2tog 2 times, sc 2 in next 4 sts, sc2tog 2 times. (12 sts)

Rnd 4: Hdc 2 in next 2 sts, sc 2 in next st; in grey, sc 2 in next st; in pink, sc 4; in grey, sc 2 in next st; in pink, sc 2 in next st, hdc 2 in next 2 sts. (20 sts)

Rnd 5: Sc 4, sc 2 in next st; in grey, sc 1, sc 2 in next st, sc 1; in pink, sc 4; in grey, sc 1, sc 2 in next st, sc 1; in pink, sc 2 in next st, sc 4. (24 sts)

Rnd 6: Sc 4, sc 2 in next st; in grey, (sc 1, sc 2 in next st) 2 times, sc 1; in pink, sc 1, sc2tog, sc 1; in grey, (sc 1, sc 2 in next st) 2 times, sc 1; in pink, sc 2 in next st, sc 4. (29 sts)

Rnd 7: Sc 6, sc 2 in next st; in grey, sc 4, sc 2 in next st, sc 1; in pink, sc 1, sc2tog; in grey, sc 1, sc 2 in next st, sc 4; in pink, sc 2 in next st, sc 6. (32 sts)

Rnd 8: Sc 8; in grey, sc 2, hdc 3, sc 2; in pink, sc2tog; in grey, sc 2, hdc 3, sc 2; in pink, sc 8. (31 sts)

Rnds 9–10: Sc 8; in grey, sc 15; in pink, sc 8. (31 sts)

Rnd 11: (Sc 2, sc2tog) 2 times; in grey, sc 5, sc2tog, sk 1, sc2tog, sc 5; in pink, (sc2tog, sc 2) 2 times. (24 sts)

Rnd 12: (Sc 1, sc2tog) 2 times; in grey, (sc 1, sc2tog) 2 times, (sc2tog, sc 1) 2 times; in pink, (sc2tog, sc 1) 2 times. (16 sts)

Cut grey.

Rnd 13: (Sc 2, sc2tog) 4 times. (12 sts)

Fasten off yarn, leaving a long tail for sewing.

The "hdc 2s" from Rnds 1 and 2 will become the lower front edge of the muzzle shaping. PM in middle of muzzle shaping if desired.

Stuff muzzle and head. If embroidering the nose, see pg 18. If using a 12mm plastic safety nose, attach nose to the front of the muzzle, one rnd above the 4-st AR, with the muzzle shaping pointing down. Position 10mm safety eyes on the sides of the head behind the muzzle.

Remove stuffing, attach the safety eye and nose backings, and then restuff head. Close hole in the back of the head. With black yarn, add a lip cleft to the muzzle, below the nose (pg 19).

With grey yarn and tapestry needle, draw a 10" piece of yarn back and forth through the head in front of the eyes, pulling gently to sink the eyes into the head. When you are happy with the head shaping, secure the yarn and sew in the ends.

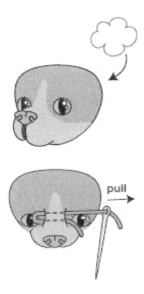

MOUTH

With pink, make a 4-st AR. Do not join. Turn. You will be working a semicircle shape.

Row 1: Ch 1, sl st 1, sc 2, sl st 1. (4 sts)

Fasten off yarn, leaving a long tail for sewing.

Sew the flat edge of the mouth behind the muzzle shaping.

Optional: Glue or sew in a small pink tongue made of felt.

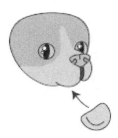

EAR (MAKE TWO)

With grey, loosely ch 5.

Row 1: Starting in second ch from hook, sc 4. Turn. (4 sts)

Row 2: Ch 1, sc 4. Turn. (4 sts)

Row 3: Ch 1, sc 1, sc2tog, sc 1. Turn. (3 sts)

Row 4: Ch 1, sc 1, sk 1, sc 1. Turn. (2 sts)

Row 5: Ch 1, sc2tog, and pm. (1 st)

Continue to sc around the entire edge of the ear until you reach the pm st from Row 5. (Sc 1, ch 2, sl st 1) in pm st. Fasten off yarn in next st, leaving an 8" tail for sewing.

Pin the flat edges of the ears about 3–4 rounds behind the eyes at a slight angle, allowing the points of the ears to stick up. Position both ears before sewing in place to ensure they are evenly attached. Attach with a whip stitch and weave in the ends.

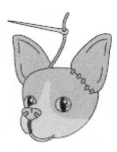

BODY

With pink, make a 4-st AR. Do not join. Turn. You will be working a semicircle shape.

Row 1: Ch 1, sc 2 in each st across. Turn. (8 sts)

Row 2: Ch 1, (sc 1, sc 2 in next st) 2 times, (sc 2 in next st, sc 1) 2 times. Turn. (12 sts)

Rows 3–6: Ch 1, sc 12. Turn. (12 sts)

Row 7: Ch 1, sc 2 in next 2 sts, sc across until 2 sts remain, sc 2 in next 2 sts. Turn. (16 sts)

Row 8: Ch 1, sc 2 in next 2 sts, sc across until 2 sts remain, sc 2 in next 2 sts. Do not turn. (20 sts)

Hold the ends of Row 8 together to create the neck opening. Work your next stitch across the gap to begin Rnd 9, and continue working the rest of the pattern in the round.

Rnd 9: Sc 3; in grey, sc 3; in pink, sc 6, sc 2 in next st; in grey, sc 4; in pink, sc 2, sc 2 in next st. (22 sts)

Rnd 10: Sc 3; in grey, sc 4; in pink, sc 5, sc2tog; in grey, sc 5; in pink, sc 1, sc2tog. (20 sts)

Rnd 11: Sc 2; in grey, sc 5; in pink, sc 3, sc2tog; in grey, sc 6; in pink, sc2tog. (18 sts)

Rnd 12: Sc 3; in grey, sc 4; in pink, sc 1, sc2tog, sc 2; in grey, sc 4; in pink, sc2tog. (16 sts)

Rnd 13: Sc 2; in grey, sc 6; in pink, sc 4; in grey, sc 2; in pink, sc 2. (16 sts)

Rnds 14–15: Sc 1; in grey, sc 8; in pink, sc 7. (16 sts)

Rnd 16: Sc2tog, sc 1; in grey, sc 5; in pink, sc2tog, sc 6. (14 sts)

Rnd 17: Sc 2; in grey, sc 2; in pink, sc 10. (14 sts)

Cut grey.

Rnd 18: (Sc 6, sc 2 in next st) 2 times. (16 sts)

Rnd 19: (Sc 6, sc2tog) 2 times. (14 sts)

Rnd 20: (Sc 5, sc2tog) 2 times. (12 sts)

Rnd 21: Sc2tog 6 times. (6 sts)

Fasten off yarn, close hole, and weave in the end.

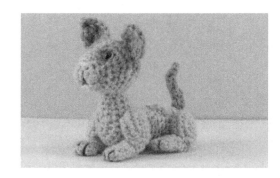

NECK

Rnd 1: Starting at the back of the neck opening, (sl st 1, ch 1, sc 1) to rejoin the pink yarn (counts as first sc st), and then sc 15 stitches evenly in a clockwise direction around the entire edge of the neck opening. (16 sts)

Rnd 2: (Sc 6, sc2tog) 2 times. (14 sts)

Rnd 3: (Sc 5, sc2tog) 2 times. (12 sts)

Rnd 4: (Sc 4, sc2tog) 2 times. (10 sts)

Rnd 5: Sc 10.

Fasten off yarn, leaving a long tail for sewing.

Stuff the body and neck. Starting at the back of the head and using a mattress stitch, sew the open edge of the neck to the back, lower sides, and bottom of the head behind the chin. If you have marking or straight pins, use them to help position the head before you sew.

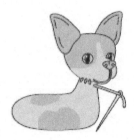

tip

This pattern also works well in a single color if you'd like to keep things simple!

LEG (MAKE FOUR)

Hip/Shoulder:

With pink, make an 8-st AR.

Rnd 1: Sc 2 in each st around. (16 sts)

Rnd 2: (Sc 1, sc 2 in next st) 8 times. (24 sts)

Rnd 3: Sc 2, ch 4, sk 4, (sc 1, sc2tog) 6 times. (18 sts)

Rnd 4: Sc2tog, sc 2 in ch-4 sp, sc2tog 6 times. (9 sts)

Fasten off yarn, leaving a long tail for sewing.

Leg:

Rnd 1: Using pink yarn, (sl st, ch 1, and sc 1) to rejoin yarn anywhere along the edge of the ch-4 opening (counts as first sc st). Sc 7 more stitches evenly around the entire edge of the ch-4 sp. (8 sts)

Rnd 2: (Sc 2, sc2tog) 2 times. (6 sts)

Rnds 3–6: Sc 6.

Rnd 7: (Sc 2, sc 2 in next st) 2 times. (8 sts)

Rnd 8: (Sc 3, sc 2 in next st) 2 times. (10 sts)

Rnd 9: Sc2tog 5 times. (5 sts)

Fasten off yarn, close hole, and weave in the end.

Stuff the legs. Close the hole in the sides of the hips/shoulders. Roll one leg up toward the side edge of the hip/shoulder. Sew the top side of the leg to the side of the hip/shoulder with a few stitches to hold it in place. Repeat the process on the other legs, but with Rnd 1 of the hips/shoulders positioned on the opposite side on two of the three remaining legs.

With black yarn and tapestry needle, draw the yarn from the bottom of the paw up through the top of the paw. Loop over the front edge of the paw and back to the starting point. Loop around one more time and cinch tightly. Repeat the whole process one more time to form the toes. Repeat on all legs. Weave in the ends.

foot bottom

To attach the front legs, position the legs on the sides of the body, lining up the tops of the shoulders with the bottom of the neck. Using a mattress stitch, sew the side edges of the shoulders to the sides of the body.

Sew the side edges of the hip to the sides of the body with the back legs level with the bottom of the body.

TAIL

With grey, loosely ch 5.

Row 1: Starting in second ch from hook, sc 4. Turn. (4 sts)

Rows 2–4: Ch 1, sc 4. Turn. (4 sts)

Row 5: Ch 1, sc 1, sc2tog, sc 1. Turn. (3 sts)

Rows 6–8: Ch 1, sc 3. (3 sts)

Row 9: Ch 1, sc 1, sk 1, sc 1. (2 sts)

Row 10: Ch 1, sc2tog. (1 st)

Fasten off yarn, leaving a long tail for sewing.

Fold tail the long way and whip stitch the edges together. Do not stuff. Sew the open edge of the tail to the back of the body.

munchkin

This adorable little shorty sometimes runs into trouble getting to those hard-to-reach scratches behind the ears. However, being closer to your food bowl can have its advantages.

Materials

F/5 3.75mm Crochet Hook
Worsted-Weight Yarn in Tan, White, and Black
Metal Tapestry Needle Stuffing
(1) Pair of 10mm Cat Safety Eyes
12mm Pink Safety Nose Scissors
Optional: Row Counter, Split/Locking Rings, Pink Felt for Tongue, Off-White Sewing Thread for Whiskers

Yarn Used

Cascade 220 #8555 Black, #8505 White, #8021 Beige

Finished Size

4" tall, 4" long

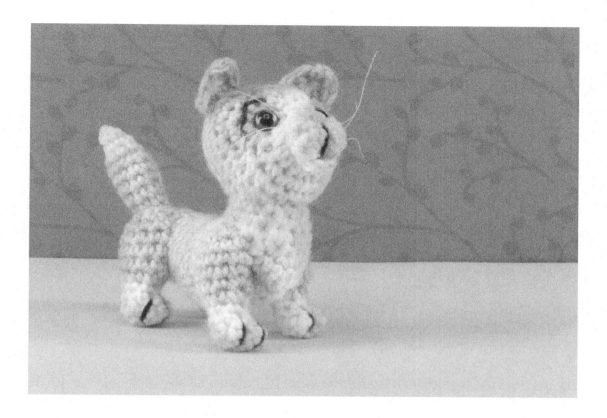

tip

Check out tips and tricks for embroidered noses and muzzle shaping on **pgs 18–19**. Refer to "Changing Colors" for cleaner color changes and "Straighter Seams in the Round" on **pgs 11–12** to help keep your cat's head markings from twisting as you work!

HEAD

With white, make a 6-st AR.

Rnd 1: Sc 1, hdc 2 in next st*, sc 2, hdc 2 in next st*, sc 1. (8 sts)

Rnd 2: Sc 1, hdc 2 in next 2 sts, sc 2, hdc 2 in next 2 sts*, sc 1. (12 sts)

Rnd 3: Sc 1, sc2tog 2 times, sc 2 in next 2 sts, sc2tog 2 times, sc 1. (10 sts)

Rnd 4: Hdc 2 in next 3 sts; in tan, sc 2 in next st; in white, sc 2 in next 2 sts; in tan, sc 2 in next st; in white, hdc 2 in next 3 sts. (20 sts)

Rnd 5: Sc 2, hdc 1, hdc 2 in next st; in tan, sc 2 in next 3 sts, sc 2; in white, sc 2; in tan, sc 2, sc 2 in next 3 sts; in white, hdc 2 in next st, hdc 1, sc 2. (28 sts)

Rnd 6: Sc 4, sc 2 in next st; in tan, sc 18; in white, sc 2 in next st, sc 4. (30 sts)

Rnd 7: Sc 6, sc 2 in next st; in tan, sc 16; in white, sc 2 in next st, sc 6. (32 sts) Cut tan.

Rnds 8–9: Sc 32.

Rnd 10: (Sc 2, sc2tog) 8 times. (24 sts)

Rnd 11: (Sc 1, sc2tog) 8 times. (16 sts)

Rnd 12: (Sc 2, sc2tog) 4 times. (12 sts)

Fasten off yarn, leaving a long tail for sewing.

The "hdc 2s" from Rnds 1 and 2 will become the lower front edge of the muzzle shaping. PM in middle of muzzle shaping if desired.

Stuff the muzzle and head. If embroidering the nose, see pg 18. If using a 12mm plastic safety nose, attach nose to the front of the muzzle, one rnd above the 6-st AR, with the muzzle shaping pointing down. Position 10mm safety eyes on the sides of the head behind the muzzle.

Remove stuffing, attach the safety eye and nose backings, and then restuff head. Close hole in the back of the head. With black yarn, add a lip cleft to the muzzle, below the nose (pg 19). With black yarn, embroider eyebrows.

With tan yarn and tapestry needle, draw a 10" piece of yarn back and forth through the head in front of the eyes, pulling gently to sink the eyes into the head. When you are happy with the head shaping, secure the yarn and sew in the ends.

Optional: If you would like to add whiskers, cut three 6" pieces of off-white thread and attach under muzzle using fringe knots. Using a sewing needle or crochet hook, draw the yarn out through the sides of the muzzle.

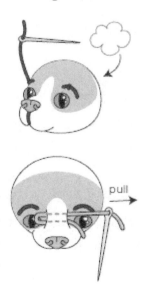

MOUTH

With white, make a 4-st AR. Do not join. Turn. You will be working a semicircle shape.

Row 1: Ch 1, sl st 1, sc 2, sl st 1. (4 sts)

Fasten off yarn, leaving an 8" tail for sewing.

Sew the flat edge of the mouth behind the muzzle shaping.

Optional: Glue or sew in a small pink tongue made of felt.

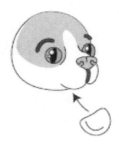

EAR (MAKE TWO)

With tan, loosely ch 4.

Row 1: Starting in second ch from hook, sc 3. Turn. (3 sts)

Row 2: Ch 1, sc 1, sk 1, sc 1. Turn. (2 sts)

Row 3: Ch 1, sc2tog, and pm. (1 st)

Continue to sc around the entire edge of the ear until you reach the pm st from Row 3. (Sc 1, ch 2, sl st 1) in pm st. Fasten off yarn in next st, leaving an 8" tail for sewing.

Pin the flat edges of the ears about 4–5 rounds behind the eyes at a slight angle, allowing the points of the ears to stick up. Position both ears before sewing in place to ensure they are evenly attached. Attach with a whip stitch and weave in the ends.

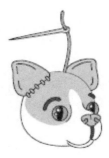

tip
Refer to "Jogless Color Change" on **pg 12** for cleaner color transitions between rounds!

BODY

With white, make a 4-st AR. Do not join. Turn. You will be working a semicircle shape.

Row 1: Ch 1, sc 2 in each st across. Turn. (8 sts)

Row 2: Ch 1, (sc 1, sc 2 in next st) 2 times, (sc 2 in next st, sc 1) 2 times. Turn. (12 sts)

Rows 3–7: Ch 1, sc 12. Turn. (12 sts)

Row 8: Ch 1, sc 2 in next 2 sts, sc across until 2 sts remain, sc 2 in next 2 sts. Turn. (16 sts)

Row 9: Ch 1, sc 2 in next 2 sts, sc across until 2 sts remain, sc 2 in next 2 sts. Do not turn. (20 sts)

Hold the ends of Row 9 together to create the neck opening. Work your next stitch across the gap to begin Rnd 10, and continue working the rest of the pattern in the round.

Rnd 10: In tan, sc 1, sc 2 in next st, sc 4, sc 2 in next st; in white, sc 6; in tan, sc 2 in next st, sc 4, sc 2 in next st, sc 1. (24 sts)

Rnd 11: Sc 9; in white, sc 6; in tan, sc 9. (24 sts)

Rnd 12: Sc 1, sc2tog, sc 4, sc2tog; in white, sc 6; in tan, sc2tog, sc 4, sc2tog, sc 1. (20 sts)

Rnd 13: Sc 7; in white, sc2tog, sc 2, sc2tog; in tan, sc 7. (18 sts)

Rnd 14: Sc 5, sc2tog; in white, sc 4; in tan, sc2tog, sc 5. (16 sts)

Rnd 15: Sc 4, sc2tog; in white, sc 4; in tan, sc2tog, sc 4. (14 sts)

Rnds 16–17: Sc 4; in white, sc 6; in tan, sc 4. (14 sts)

Rnd 18: Sc 2, sc2tog; in white, sc 6, in tan, sc2tog, sc 2. (12 sts)

Rnd 19: Sc 1, sc2tog; in white, sc 6, in tan, sc2tog, sc 1. (10 sts)

Cut tan.

Rnd 20: In white, sc2tog 5 times. (5 sts)

Fasten off yarn, close hole, and weave in the end.

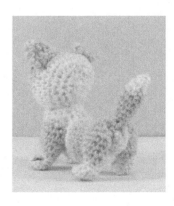

NECK

Rnd 1: Starting at the back of the neck opening, (sl st 1, ch 1, sc 1) to rejoin the white yarn (counts as first sc st), and then sc 17 stitches evenly in a clockwise direction around the entire edge of the neck opening. (18 sts)

Rnd 2: Sc 18.

Rnd 3: (Sc 7, sc2tog) 2 times. (16 sts)

Fasten off yarn, leaving a long tail for sewing.

Stuff the body and neck. Starting at the back of the head and using a mattress stitch, sew the open edge of the neck to the back, lower sides, and bottom of the head behind the chin. If you have marking or straight pins, use them to help position the head before you sew.

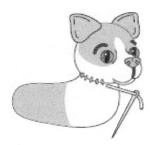

LEG (MAKE FOUR)

Starting with white, make a 4-st AR.

Rnd 1: Sc 2 in each st around. (8 sts)

Rnd 2: Sc 2, hdc 4*, sc 2. (8 sts)

Rnd 3: Sc 2, sc2tog 2 times, sc 2. (6 sts)

Rnd 4: Sc 6.

Change to tan.

Rnd 5: (Sc 2, sc 2 in next st) 2 times. (8 sts)

Rnd 6: (Sc 3, sc 2 in next st) 2 times. (10 sts)

Rnd 7: (Sc 4, sc 2 in next st) 2 times. (12 sts)

Rnds 8–9: Sc 12.

Rnd 10: (Sc 1, sc2tog) 4 times. (8 sts)

Fasten off yarn, stuff leg, and close hole, leaving a long tail for sewing.

The "hdc 4" from Rnd 2 will become the front of the paw.

With black yarn and tapestry needle, draw the yarn from the bottom of the paw up through the top of the paw. Loop over the front edge of the paw and back to the starting point. Loop around one more time and cinch tightly. Repeat the

whole process one more time to form the toes. Repeat on all legs. Weave in the ends.

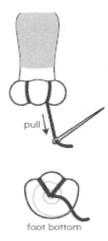

To attach the front legs, line up the tops of the legs with Rnd 1 of the neck, taking care to keep the paws facing forward. Using a mattress stitch, sew the side edges of the upper part of the legs to the sides of the body. Line up the tops of the back legs with the front legs and attach the back legs to the back half of the body in the same manner as the front legs.

To keep the legs from splaying, attach white yarn to the inside surface of one front leg, pass yarn through the body to the inside surface of the opposite front leg, and then back again through the body to the starting point. Pull to draw the legs close to the body, tie off the yarn, and weave in the end. Repeat on back legs.

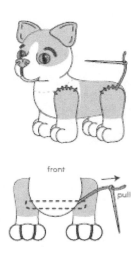

TAIL

With tan, make a 6-st AR.

Rnd 1: Sc 6.

Rnd 2: (Sc 2, sc 2 in next st) 2 times. (8 sts)

Rnd 3: Sc 8.

Rnd 4: (Sc 3, sc 2 in next st) 2 times. (10 sts)

Rnds 5–6: Sc 10.

Change to white.

Rnd 7: (Sc 3, sc2tog) 2 times. (8 sts)

Lightly stuff tail.

Rnd 8: (Sc 2, sc2tog) 2 times. (6 sts)

Rnd 9: Sc2tog 3 times. (3 sts)

Fasten off yarn, leaving a long tail for sewing.

Finish stuffing the tail. Use the back of the crochet hook if needed. Sew the open edge of the tail to the back of the body.

exotic shorthair

Don't let the smushed face and upturned lip fool you: this exotic sweetheart is all about the cuddles and loves nothing more than a warm lap.

Materials

F/5 3.75mm Crochet Hook
Worsted-Weight Yarn in White, Grey, and Black
Metal Tapestry Needle Stuffing
(1) Pair of 10mm Cat Safety Eyes
12mm Pink Safety Nose Scissors
Optional: Row Counter, Split/Locking Rings, Pink Felt for Tongue, Off-White Sewing Thread for Whiskers

Yarn Used

Cascade 220 #8555 Black, #8012 Doeskin Heather, #8505 White

Finished Size

4.5" tall, 4" long

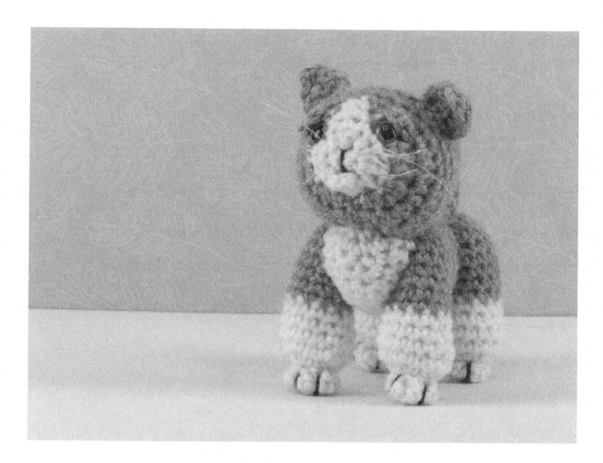

tip

Check out tips and tricks for embroidered noses and muzzle shaping on pgs 18–19. Refer to "Changing Colors" for cleaner color changes and "Straighter Seams in the Round" on pgs 11–12 to help keep your cat's head markings from twisting as you work!

HEAD

Starting with white, make an 8-st AR.

Rnd 1: Sc 1, hdc 2 in next st*, sc 2 in next 4 sts, hdc 2 in next st*, sc 1. (14 sts)

Rnd 2: Sc 1, sc2tog, sc 8, sc2tog, sc 1. (12 sts)

Rnd 3: In grey, hdc 2 in next 4 sts, sc 2 in next st; in white, sc 2 in next 2 sts; in grey, sc 2 in next st, hdc 2 in next 4 sts. (24 sts)

Rnd 4: Sc 2, hdc 2 in next 4 sts, sc 5; in white, sc 2; in grey, sc 5, hdc 2 in next 4 sts, sc 2. (32 sts)

Cut white.

Rnd 5: Sc 4, hdc 2 in next 3 sts, sc 18, hdc 2 in next 3 sts, sc 4. (38 sts)

Rnd 6–7: Sc 15, hdc 8, sc 15. (38 sts)

Rnd 8: Sc 4, sc2tog 3 times, sc 18, sc2tog 3 times, sc 4. (32 sts)

Rnds 9–10: Sc 32.

Rnd 11: (Sc 2, sc2tog) 8 times. (24 sts)

Rnd 12: (Sc 1, sc2tog) 8 times. (16 sts)

Rnd 13: (Sc 2, sc2tog) 4 times. (12 sts)

Fasten off yarn, leaving a long tail for sewing.

The "hdc 2s" at the beginning and end of Rnd 1 will become the lower front edge of the muzzle shaping. PM in middle of muzzle shaping if desired.

Stuff muzzle and head. If embroidering the nose, see pg 18. If using a 12mm plastic safety nose, attach nose to front of the muzzle, one rnd above the 8-st AR, with the muzzle shaping pointing down. Position 10mm safety eyes on the sides of the head behind the muzzle.

Remove stuffing, attach the safety eye and nose backings, and then restuff head. Close hole in the back of the head. With black yarn, add a lip cleft to the muzzle, below the nose (pg 19).

With grey yarn and tapestry needle, draw a 10" piece of yarn back and forth through the head in front of the eyes, pulling gently to sink the eyes into the head. When you are happy with the head shaping, secure the yarn, and sew in the ends.

Optional: If you would like to add whiskers, cut three 6" pieces of off-white thread and attach under the muzzle using fringe knots. Using a sewing needle or crochet hook, draw the yarn out through the sides of the muzzle.

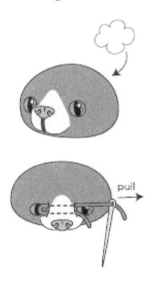

MOUTH

With white, make a 4-st AR. Do not join. Turn. You will be working a semicircle shape.

Row 1: Ch 1, sl st 1, sc 2, sl st 1. (4 sts)

Fasten off yarn, leaving a long tail for sewing.

Sew the flat edge of the mouth behind the muzzle shaping.

Optional: Glue or sew in a small pink tongue made of felt.

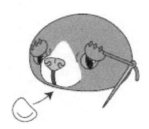

EYELID (MAKE TWO)

With grey, make a 4-st AR. Do not join, but pull shaping closed into a semicircle shape.

Fasten off yarn, leaving a long tail for sewing.

Sew flat edge of eyelid above the eye, allowing curved edge to hang over the top of the eye.

EAR (MAKE TWO)

With grey, loosely ch 4.

Row 1: Starting in second ch from hook, sc 3. Turn. (3 sts)

Row 2: Ch 1, sc 1, sk 1, sc 1. Turn. (2 sts)

Row 3: Ch 1, sc2tog, and pm. (1 st)

Continue to sc around entire edge of ear until you reach the pm st from Row 3. (Sc 1, ch 2, sl st 1) in pm st.

Fasten off yarn in next st, leaving an 8" tail for sewing.

Pin the flat edges of the ears about 4–5 rounds behind the eyes at a slight angle, allowing the points of the ears to stick up. Position both ears before sewing in place to ensure they are evenly attached. Attach with a whip stitch and weave in the ends.

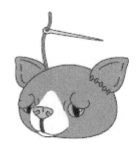

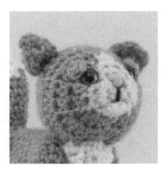

BODY

With white, make a 4-st AR. Do not join. Turn. You will be working a semicircle shape.

Row 1: Ch 1, sc 2 in each st across. Turn. (8 sts)

Row 2: Ch 1, (sc 1, sc 2 in next st) 2 times, (sc 2 in next st, sc 1) 2 times. Turn. (12 sts)

Rows 3–4: Ch 1, sc 12. Turn. (12 sts)

Starting on Row 5, keep yarn tails in back of work, then proceed to keep yarn tails and floats for Rows 6–9 on the same side as the Row 5 yarn tails.

Row 5: In grey, ch 1, sc 2; in white, sc 8; in grey, sc 2. Turn. (12 sts)

Row 6: Ch 1, sc 3; in white, sc 6; in grey, sc 3. Turn. (12 sts)

Row 7: Ch 1, sc 2 in next 2 sts, sc 2; in white, sc 4; in grey, sc 2, sc 2 in next 2 sts. Turn. (16 sts)

Row 8: Ch 1, sc 2 in next 2 sts, sc 4; in white, sc 4; in grey, sc 4, sc 2 in next 2 sts. Turn. (20 sts)

Row 9: Ch 1, sc 8; in white, sc 4; in grey, sc 8. Do not turn. (20 sts)

Hold the ends of Row 9 together to create the neck opening. Work your next stitch across the gap to begin Rnd 10, and continue working the rest of the pattern in the round.

Rnd 10: Sc 4, sc 2 in next st, sc 3, sc 2 in next st; in white, sc 2; in grey, sc 2 in next st, sc 3, sc 2 in next st, sc 4. (24 sts)

Cut white. Cont in grey.

Rnd 11: Sc 24.

Rnd 12: (Sc 4, sc2tog) 4 times. (20 sts)

Rnds 13–14: Sc 20.

Rnd 15: (Sc 8, sc2tog) 2 times. (18 sts)

Rnds 16–17: Sc 18.

Rnd 18: (Sc 1, sc2tog) 6 times. (12 sts)

Rnd 19: Sc2tog 6 times. (6 sts)

Fasten off yarn, close hole, and weave in the end.

Continue to use the straight seam technique (pg 12) on the neck.

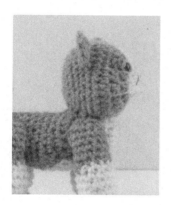

NECK

Rnd 1: Starting at the back of the neck opening, (sl st, ch 1 and sc 1) to rejoin grey yarn (counts as first sc st). Working in a clockwise direction, sc 4 stitches to where the grey edge ends. In white, sc 10 evenly along white edge; change to grey, sc 5 to end of round. (20 sts)

Rnd 2: Sc 2, sc2tog, sc 1, sc2tog; in white, sc 1, sc2tog 2 times, sc 1; in grey, sc2tog, sc 1, sc2tog, sc 2. (14 sts)

Fasten off yarn, leaving a long tail for sewing.

Stuff the body and neck. Starting at the back of the head and using the mattress stitch, sew the open edge of the neck to the back, lower sides, and bottom of the head behind the chin. If you have marking or straight pins, use them to help position the head before you sew.

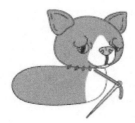

tip

Refer to "Jogless Color Change" on **pg 12** for cleaner color transitions between rounds!

LEG (MAKE FOUR)

Starting with white, make a 4-st AR.

Rnd 1: Sc 2 in each st around. (8 sts)

Rnd 2: Sc 2, hdc 4*, sc 2. (8 sts)

Rnd 3: Sc 2, sc2tog 2 times, sc 2. (6 sts)

Stuff paw.

Rnd 4: Sc 2 in each st around. (12 sts)

Rnd 5: (Sc 1, sc 2 in next st) 6 times. (18 sts)

Rnd 6: (Sc 7, sc2tog) 2 times. (16 sts)

Rnd 7: (Sc 6, sc2tog) 2 times. (14 sts)

Rnd 8: (Sc 5, sc2tog) 2 times. (12 sts)

Cut white. Change to grey.

Rnds 9–13: Sc 12.

Rnd 14: (Sc 4, sc2tog) 2 times. (10 sts)

Rnd 15: Sc 10.

Fasten off yarn, stuff leg, and close hole, leaving a long tail for sewing.

The "hdc 4" from Rnd 2 will become the front of the paw.

With black yarn and tapestry needle, draw the yarn from the bottom of the paw up through the top of the paw. Loop over the front edge of the paw and back to the starting point. Loop around one more time and cinch tightly. Repeat the whole process one more time to form the toes. Repeat on all legs. Weave in the ends.

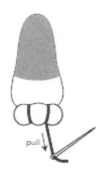

foot bottom

To attach the front legs, line up the tops of the legs with Rnd 1 of the neck, taking care to keep the paws facing forward. Using a mattress stitch, sew the side edges of the upper part of the legs to the sides of the body. Line up the tops of the back legs with the front legs and attach the back legs to the back half of the body in the same manner as the front legs.

To keep the legs from splaying, attach grey yarn to the inside surface of one front leg, pass yarn through the body to the inside surface of the opposite front leg, and then back again through the body to the starting point. Pull to draw the legs close to the body, tie off the yarn, and weave in the end. Repeat on back legs.

front

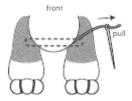

pull

TAIL

Starting with grey, make a 6-st AR.

Rnd 1: Sc 6.

Rnd 2: (Sc 2, sc 2 in next st) 2 times. (8 sts)

Rnds 3–4: Sc 8.

Rnd 5: (Sc 3, sc 2 in next st) 2 times. (10 sts)

Rnds 6–8: Sc 10.

Change to white.

Rnd 9: (Sc 3, sc2tog) 2 times. (8 sts)

Stuff tail lightly.

Rnd 10: (Sc 2, sc2tog) 2 times. (6 sts)

Rnd 11: Sc2tog 3 times. (3 sts)

Fasten off yarn, leaving a long tail for sewing.

Finish stuffing the tail. Use the back of the crochet hook if needed. Sew the open edge of the tail to the back of the body.

bengal

A little tiger in your living room, this Bengal is on the prowl and is proud to show off its latest kill. Any unwelcome mice won't bother you anymore.

Materials

F/5 3.75mm Crochet Hook
Worsted-Weight Yarn in Black, Dark Brown, Orange, Ivory, and Reddish Brown
Metal Tapestry Needle Stuffing
(1) Pair of 10mm Cat Safety Eyes
12mm Pink Safety Nose Scissors
Optional: Row Counter, Split/Locking Rings, Pink Felt for Tongue, Off-White Sewing Thread for Whiskers

Yarn Used

Cascade 220 #8555 Black, #7826 California Poppy, #2435 Japanese Maple, #8686 Brown, #8010 Natural

Finished Size

5" tall, 5" long

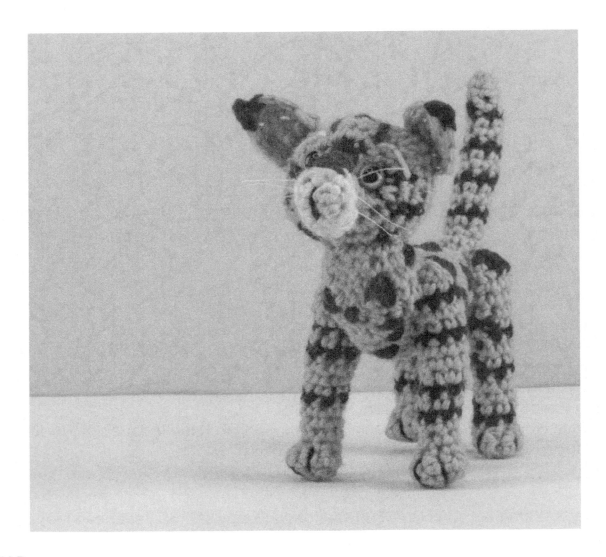

HEAD

With ivory, make a 4-st AR.

Rnd 1: Hdc 2 in next st*, sc 2 in next 2 sts, hdc 2 in next st*. (8 sts)

Rnd 2: Hdc 2 in next 2 sts*, sc 4, hdc 2 in next 2 sts. (12 sts)

Rnd 3: Sc2tog 2 times; in orange, sc 2 in next st; in dark brown, sc 2; in orange, sc 2 in next st; in ivory, sc2tog 2 times. (10 sts)

Rnd 4: Hdc 2 in next st; in orange, hdc 2 in next st; in dark brown, sc 1; in orange, sc 2 in next st; in dark brown, sc 2; in orange, sc 2 in next st; in dark brown, sc 1; in orange, hdc 2 in next st; in ivory, hdc 2 in next st. (16 sts)

Cut ivory.

Rnd 5: In orange, sc 2, sc 2 in next st; (in dark brown, sc 1; in orange, sc 1) in next st; in dark brown, sc 1; in orange, sc 2 in next 6 sts; in dark brown, sc 1; (in orange, sc 1; in dark brown, sc 1) in next st; in orange, sc 2 in next st, sc 2. (26 sts)

Rnd 6: In orange, sc 2; in dark brown, sc 1; in orange, sc 2 in next st; in dark brown, sc 1; in orange, sc 2 in next st; in dark brown, sc 1; in orange, sc 12; in dark brown, sc 1; in orange, sc 2 in next st; in dark brown, sc 1; in orange, sc 2 in next st; in dark brown, sc 1; in orange, sc 2. (30 sts)

Rnd 7: In orange, sc 2; in dark brown, sc 1; in orange, sc 1, sc 2 in next st; in dark brown, sc 1; in orange, sc 3, hdc 2 in next st, sc 4; in dark brown, sc2tog; in orange, sc 4, hdc 2 in next st, sc 3; in dark brown, sc 1; in orange, sc 2 in next st, sc 1; in dark brown, sc 1; in orange, sc 2. (33 sts)

Rnd 8: Sc 15; in dark brown, sc 1, sc 2 in next st, sc 1; in orange, sc 15. (34 sts)

Rnd 9: Sc 14, sc 2 in next st; in dark brown, sc 4; in orange, sc 2 in next st, sc 14. (36 sts)

Rnd 10: (Sc2tog, sc 1) 5 times, sc2tog; in dark brown, sc 2; in orange, sc2tog, (sc 1, sc2tog) 5 times. (24 sts)

Rnd 11: (Sc2tog, sc 1) 3 times, sc2tog; in dark brown, sc 2; in orange, sc2tog, (sc 1, sc2tog) 3 times. (16 sts)

Rnd 12: (Sc 2, sc2tog) 4 times. (12 sts)

The "hdc 2s" from Rnds 1 and 2 will become the lower front edge of the muzzle shaping. PM in middle of muzzle shaping if desired.

Stuff muzzle and head. If embroidering the nose, see pg 18. If using a 12mm plastic safety nose, attach nose to front of the muzzle, one rnd above the 4-st AR, with the muzzle shaping pointing down. Position 10mm safety eyes on the sides of the head behind the muzzle.

Remove stuffing, attach the safety eye and nose backings, and then restuff head. Close hole in the back of the head. With black yarn, add a lip cleft to the muzzle, below the nose (pg 19). With ivory yarn, embroider eyebrows.

With orange yarn and tapestry needle, draw a 10" piece of yarn back and forth through the head in front of the eyes, pulling gently to sink the eyes into the head. When you are happy with the head shaping, secure the yarn and sew in the ends. With reddish brown, embroider two long stitches down the sides of the nose bridge and 3–5 horizontal satin stitches directly behind the nose.

Optional: If you would like to add whiskers, cut three 6" pieces of off-white thread and attach under the muzzle using fringe knots. Using a sewing needle or crochet hook, draw the yarn out through the sides of the muzzle.

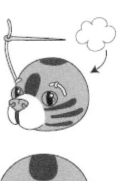

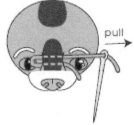

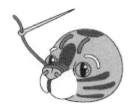

MOUTH

With ivory, make a 4-st AR. Do not join. Turn. You will be working a semicircle shape.

Row 1: Ch 1, sl st 1, sc 2, sl st 1. (4 sts)

Fasten off yarn, leaving a long tail for sewing.

Sew the flat edge of the mouth behind the muzzle shaping.

Optional: Glue or sew in a small pink tongue made of felt.

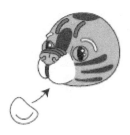

EAR (MAKE TWO)

With orange, loosely ch 5.

Row 1: Starting in second ch from hook, sc 4. Turn. (4 sts)

Row 2: Ch 1, sc 1, sc2tog, sc 1. Turn. (3 sts)

Row 3: Ch 1, sc 1, sk 1, sc 1. Turn. (2 sts)

Row 4: Ch 1, sc2tog, and pm. (1 st)

Continue to sc around the entire edge of the ear until you reach the pm st from Row 4. In dark brown, (sc 1, ch 2, sl st 1) in pm st. Fasten off yarn in next st, leaving an 8" tail for sewing.

Pin the flat edges of the ears about 4–5 rounds behind the eyes at a slight angle, allowing the points of the ears to stick up. Position both ears before sewing them in place to ensure they are evenly attached. Attach with a whip stitch and weave in the ends.

BODY

With orange, make a 4-st AR. Do not join. Turn. You will be working a semicircle shape.

Row 1: Ch 1, sc 2 in each st across. Turn. (8 sts)

Row 2: Ch 1, (sc 1, sc 2 in next st) 2 times, (sc 2 in next st, sc 1) 2 times. Turn. (12 sts)

Rows 3–6: Ch 1, sc 12. Turn. (12 sts)

Row 7: Ch 1, sc 2 in next 2 sts, sc across until 2 sts remain, sc 2 in next 2 sts. Turn. (16 sts)

Row 8: Ch 1, sc 2 in next 2 sts, sc across until 2 sts remain, sc 2 in next 2 sts. Do not turn. (20 sts)

Hold the ends of Row 8 together to create the neck opening. Work your next stitch across the gap to begin Rnd 9, and continue working the rest of the pattern in the round.

Rnd 9: (Sc 4, sc 2 in next st) 4 times. (24 sts)

Rnd 10: (Sc 4, sc2tog) 4 times. (20 sts)

Rnd 11: Sc 20.

Rnd 12: (Sc 3, sc2tog) 4 times. (16 sts)

Rnd 13: Sc 16.

Rnd 14: (Sc 6, sc2tog) 2 times. (14 sts)

Rnds 15–17: Sc 14.

Rnd 18: (Sc 5, sc2tog) 2 times. (12 sts)

Rnd 19: Sc2tog 6 times. (5 sts)

Fasten off yarn, close hole, and weave in the end.

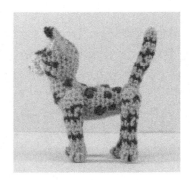

Rnd 1: Starting at the back of the neck opening, (sl st 1, ch 1, sc 1) to rejoin the orange yarn (counts as first sc st), and then sc 15 stitches evenly in a clockwise direction around the entire edge of the neck opening. (16 sts)

Rnd 2: Sc 16.

Rnd 3: (Sc 6, sc2tog) 2 times. (14 sts)

Rnd 4: (Sc 5, sc2tog) 2 times. (12 sts)

Fasten off yarn, leaving an 8" tail for sewing.

Stuff body and neck. Starting at the back of the head, and using the mattress stitch, sew the open edge of the neck to the back, lower sides, and bottom of the head behind the chin. If you have marking or straight pins, use them to help position the head before you sew.

tip

Refer to "Jogless Color Change" on **pg 12** for cleaner color transitions between rounds!

LEG (MAKE FOUR)

With orange, make a 4-st AR.

Rnd 1: Sc 2 in each st around. (8 sts)

Rnd 2: Sc 2, hdc 4*, sc 2. (8 sts)

Rnd 3: Sc 2, sc2tog 2 times, sc 2. (6 sts)

Randomly make every 1–4 rnds dark brown to create uneven stripes. You should have 3–4 stripes on each leg when the leg is done.

Rnds 4–8: Sc 6.

Stuff leg.

Rnd 9: (Sc 2, sc 2 in next st) 2 times. (8 sts)

Rnds 10–13: Sc 8.

Rnd 14: (Sc 3, sc 2 in next st) 2 times. (10 sts)

Rnd 15: Sc 10.

Rnd 16: (Sc 3, sc2tog) 2 times. (8 sts)

Finish stuffing the leg. Fasten off yarn and close hole, leaving an 8" tail for sewing.

The "hdc 4" from Rnd 2 will become the front of the paw.

With black yarn and tapestry needle, draw the yarn from the bottom of the paw up through the top of the paw. Loop over the front edge of the paw and back to the starting point. Loop around one more time and cinch tightly. Repeat the whole process one more time to form the toes. Repeat on all legs. Weave in the ends.

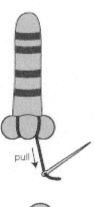

pull

foot bottom

To attach the front legs, line up the tops of the legs with Rnd 1 of the neck, taking care to keep the paws facing forward. Using a mattress stitch, sew the side edges of the upper part of the legs to the sides of the body. Line up the tops

of the back legs with the front legs and attach the back legs to the back half of the body in the same manner as the front legs.

To keep the legs from splaying, attach orange yarn to the inside surface of one front leg, pass yarn through the body to the inside surface of the opposite front leg, and then back again through the body to the starting point. Pull to draw the legs close to the body, tie off the yarn, and weave in the end. Repeat on the back legs.

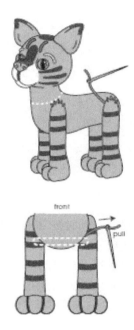

TAIL

With orange, make a 6-st AR.

Make every third rnd dark brown.

Rnds 1–14: Sc 6.

Rnd 15: In orange, (sc 1, sc 2 in next st) 3 times. (9 sts)

Fasten off yarn, leaving a long tail for sewing.

Lightly stuff the tail. Use the back of the crochet hook if needed. Sew the open edge of the tail to the back of the body.

Add spots by embroidering small groups of satin stitches (pg 16), each made up of 3–4 stitches, all over the body.

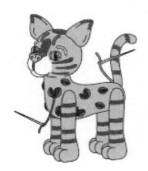

abyssinian

A catnap is the perfect way to start the day. Or spend the afternoon. Or end the day. This kitty has it all figured out.

Materials

G/6 4mm or F/5 3.75mm Crochet Hook
Worsted-Weight Yarn in Black, Reddish Brown, Light Brown, Dark Brown, and Ivory
Metal Tapestry Needle Stuffing
(1) Pair of 9mm Black Safety Eyes
12mm Pink Safety Nose Scissors
Optional: Row Counter, Split/Locking Rings, Pink Felt for Tongue, Off-White Sewing Thread for Whiskers

Yarn Used

Cascade 220 #8555 Black, #2435 Japanese Maple, #9600 Antiqued Heather, #1208 Tan, #8686 Brown

Finished Size

2" tall, 5" long

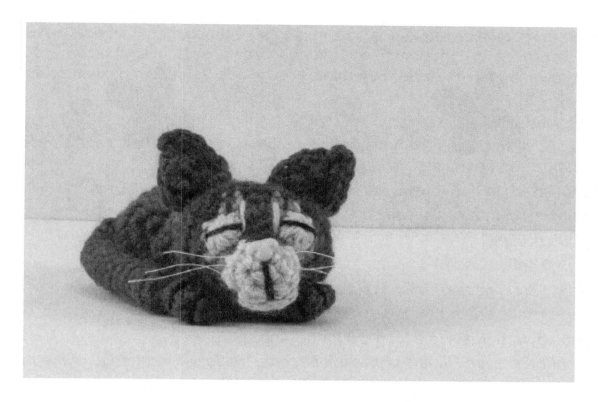

tip

Check out tips and tricks for embroidered noses and muzzle shaping on **pgs 18–19**. Refer to "Changing Colors" for cleaner color changes and "Straighter Seams in the Round" on **pgs 11–12** to help keep your cat's head markings from twisting as you work!

HEAD

With ivory, make a 4-st AR.

Rnd 1: Hdc 2 in next st*, sc 2 in next 2 sts, hdc 2 in next st*. (8 sts)

Rnd 2: Hdc 2 in next 2 sts*, sc 4, hdc 2 in next 2 sts. (12 sts)

Rnd 3: Sc2tog 2 times; in light brown, sc 2 in next st; in reddish brown, sc 2; in light brown, sc 2 in next st; in ivory, sc2tog 2 times. (10 sts)

Cut ivory.

Rnd 4: In reddish brown, hdc 2 in next 2 sts; in light brown, sc 2 in next 2 sts; in reddish brown, sc 2; in light brown, sc 2 in next 2 sts; in reddish brown, hdc 2 in next 2 sts. (18 sts)

Rnd 5: In reddish brown, sc 2, sc 2 in next 2 sts; in light brown, sc 3, sc 2 in next st; in reddish brown, sc 2; in light brown sc 2 in next st, sc 3; in reddish brown, sc 2 in next 2 sts, sc 2. (24 sts)

Rnd 6: In reddish brown, (sc 2, sc 2 in next st) 2 times, hdc 2; in dark brown, hdc 2 in next st; in light brown, sc 2; in dark brown, sc 2; in light brown, sc 2; in dark brown, hdc 2 in next st; in reddish brown, hdc 2, (sc 2 in next st, sc 2) 2 times. (30 sts)

Cut light brown.

Rnd 7: Sc 4, hdc 2 in next 3 sts, hdc 3; in dark brown, sc 10; in reddish brown, hdc 3, hdc 2 in next 3 sts, sc 4. (36 sts)

Rnd 8: Sc 14; in dark brown, sc 8; in reddish brown, sc 14. (36 sts)

Rnd 9: Sc 16; in dark brown, sc 4; in reddish brown, sc 16. (36 sts)

Cut dark brown.

Rnd 10: (Sc2tog, sc 1) 6 times, (sc 1, sc2tog) 6 times. (24 sts)

Rnd 11: (Sc 1, sc2tog) 8 times. (16 sts)

Rnd 12: (Sc 2, sc2tog) 4 times. (12 sts)

Fasten off yarn, leaving a long tail for sewing.

The "hdc 2s" from Rnds 1 and 2 will become the lower front edge of the muzzle shaping. PM in middle of muzzle shaping if desired.

Stuff muzzle and head. If embroidering the nose, see pg 18. If using a 12mm plastic safety nose, attach nose to front of muzzle, one rnd above the 4-st AR, with the muzzle shaping pointing down. Position 9mm safety eyes on the sides of the head within the light-brown areas.

Remove stuffing, attach the safety eye and nose backings, and then restuff head. Close hole in the back of the head. With black yarn, add a lip cleft to the muzzle, below the nose (pg 19). With ivory yarn, embroider two long stitches down the sides of the reddish-brown nose bridge. With dark-brown yarn, sew one vertical short stitch in each of the light-brown areas and 2–3 horizontal satin stitches directly behind the nose.

With reddish-brown yarn and tapestry needle, draw a 10" piece of yarn back and forth through the head in front of the eyes, pulling gently to sink the eyes into the head. When you are happy with the head shaping, secure the yarn and sew in the ends. With reddish brown, embroider two long stitches down the sides of the nose bridge and 3–5 horizontal satin stitches directly behind the nose.

Optional: If you would like to add whiskers, cut three 6" pieces of off-white thread and attach under the muzzle using fringe knots. Using a sewing needle or crochet hook, draw the yarn out through the sides of the muzzle.

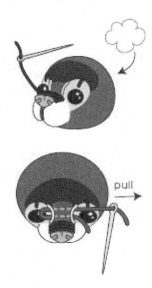

EYELID (MAKE TWO)

With ivory, make an 8-st AR. Sl st to fasten off yarn in first st of 8-st AR to form a circle. If available, try going down one hook size when making the eyelids.

Sew eyelids to the front of the cat's face over the black safety eyes (the eyes will provide structure and shaping to the lids). With black yarn, sew a long horizontal stitch over the front of the eyes to define the tops and bottoms of the eyelids.

MOUTH

With ivory, make a 4-st AR. Do not join. Turn. You will be working a semicircle shape.

Row 1: Ch 1, sl st 1, sc 2, sl st 1. (4 sts)

Fasten off yarn, leaving a long tail for sewing.

Sew the flat edge of the mouth behind the muzzle shaping.

Optional: Glue or sew in a small pink tongue made of felt.

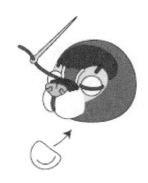

With reddish brown, loosely ch 5.

Row 1: Starting in second ch from hook, sc 4. Turn. (4 sts)

Row 2: Ch 1, sc 1, sc2tog, sc 1. Turn. (3 sts)

Row 3: Ch 1, sc 1, sk 1, sc 1. Turn. (2 sts)

Row 4: Ch 1, sc2tog, and pm. (1 st)

Continue to sc around entire edge of the ear until you reach the pm st from Row 4. (Sc 1, ch 2, sl st 1) in pm st. Fasten off yarn in next st, leaving an 8" tail for sewing.

Pin the flat edges of the ears about 3–4 rounds behind the eyes at a slight angle, allowing the ears to lie back in a flat pose. Position both ears before sewing them in place to ensure they are evenly attached. Attach with a whip stitch and weave in the ends.

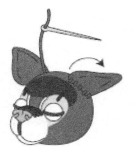

BODY

With reddish brown, make a 6-st AR.

Rnd 1: Sc 2 in each st around. (12 sts)

Rnd 2: (Sc 1, sc 2 in next st) 2 times; in ivory, sc 1, sc 2 in next 2 sts, sc 1; in reddish brown, (sc 2 in next st, sc 1) 2 times. (18 sts)

Rnds 3–4: Sc 6; in ivory, sc 6; in reddish brown, sc 6. (18 sts)

Rnd 5: Sc 5, sc 2 in next st; in ivory, sc 6; in reddish brown, sc 2 in next st, sc 5. (20 sts)

Rnds 6–8: Sc 7; in ivory, sc 6; in reddish brown, sc 7. (20 sts)

Rnd 9: Sc 3, sc2tog 2 times; in ivory, sc 6; in reddish brown, sc2tog 2 times, sc 3. (16 sts)

Rnd 10: Sc 5; in ivory, sc2tog, sc 2, sc2tog; in reddish brown, sc 5. (14 sts)

Rnds 11–12: Sc 5; in ivory, sc 4; in reddish brown, sc 5. (14 sts)

Rnd 13: Sc 4, sc 2 in next st; in ivory, sc 4; in reddish brown, sc 2 in next st, sc 4. (16 sts)

Rnds 14–15: Sc 6; in ivory, sc 4; in reddish brown, sc 6. (16 sts)

Rnd 16: (Sc 1, sc2tog) 2 times; in ivory, sc 4; in reddish brown, (sc2tog, sc 1) 2 times. (12 sts)

Stuff body.

Rnd 17: Sc 4; in ivory, sc 4; in reddish brown, sc 4. (12 sts)

Rnd 18: Sc2tog 2 times; in ivory, sc 4; in reddish brown, sc2tog 2 times. (8 sts)
Fasten off yarn, leaving the neck edge open.

Stuff upper body and neck lightly. Sew the open edge of the neck to the back of the head. If you have marking or straight pins, use them to help position the head before you sew.

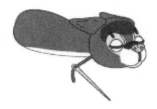

LEG (MAKE FOUR)

Hip/Shoulder:

With reddish brown, make an 8-st AR.

Rnd 1: Sc 2 in each st around. (16 sts)

Rnd 2: (Sc 1, sc 2 in next st) 8 times. (24 sts)

Rnd 3: Sc 2, ch 4, sk 4, (sc 1, sc2tog) 6 times. (18 sts)

Rnd 4: Sc2tog, sc 2 in ch-4 sp, sc2tog 6 times. (9 sts)

Fasten off yarn, leaving a long tail for sewing.

Leg:

Rnd 1: With reddish brown, (sl st, ch 1 and sc 1) to rejoin yarn anywhere along the edge of the ch-4 opening (counts as first sc st). Sc 7 more stitches evenly around the entire edge of the ch-4 sp. (8 sts)

Rnd 2: (Sc 2, sc2tog) 2 times. (6 sts)

Rnds 3–6: Sc 6.

Rnd 7: (Sc 2, sc 2 in next st) 2 times. (8 sts)

Rnd 8: (Sc 3, sc 2 in next st) 2 times. (10 sts)

Rnd 9: Sc2tog 5 times. (5 sts)

Fasten off yarn, close hole, and weave in the end.

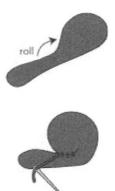

For back legs only, stuff legs and hips. Close the holes in the side of the hips. Roll the leg up toward the side edge of the hips. Sew the top side of the leg to the side of the hips with a few stitches to hold it in place. Repeat process on the other leg, but with Rnd 1 of the hip positioned on the opposite side.

For the front legs, lightly stuff two legs and shoulders but do not roll legs up toward the shoulders.

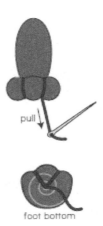

With black yarn and tapestry needle, draw the yarn from the bottom of the paw up through the top of the paw. Loop over the front edge of the paw and back to the starting point. Loop around one more time and cinch tightly. Repeat the whole process one more time to form the toes. Repeat on all legs. Weave in the ends.

Sew the side edges of the shoulders to the sides of the body behind the head. Place the paws behind the chin, under the cheeks, and secure in place with a few stitches. Sew the side edges of the hips to the back half of the body.

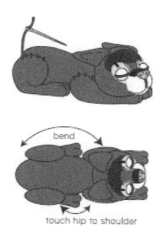

Curl body around until the inside hip and shoulder touch. Tuck the inside back leg under the body until the paw lines up with the cat's chest. Sew the paw to the chest at the base of the head. Line up the outside back leg along the edge of the body and sew in place with a few stitches.

TAIL

With reddish brown, make a 6-st AR.

Rnds 1–14: Sc 6.

Rnd 15: (Sc 1, sc 2 in next st) 3 times. (9 sts)

Fasten off yarn, leaving a long tail for sewing.

Lightly stuff the tail. Use the back of the crochet hook if needed. Sew the open edge of the tail to the back of the body. Wrap tail around the inside edge of the body until it lines up against the inside front leg's paw. Secure in place with a few stitches.

top

chartreux

This lucky little kitty has almost found the perfect cat toy. If only it were attached to a delicately-worked piece of crochet …

Materials

F/5 3.75mm Crochet Hook
Worsted-Weight Yarn in Grey, Black, and Purple
Metal Tapestry Needle Stuffing
(1) Pair of 10mm Cat Safety Eyes
12mm Pink Safety Nose Scissors
Optional: Row Counter, Split/Locking Rings, Pink Felt for Tongue, Off-White Sewing Thread for Whiskers

Yarn Used

Cascade 220 #8555 Black, #9473 Gris, #8762 Deep Lavender

Finished Size

6" tall, 5" long

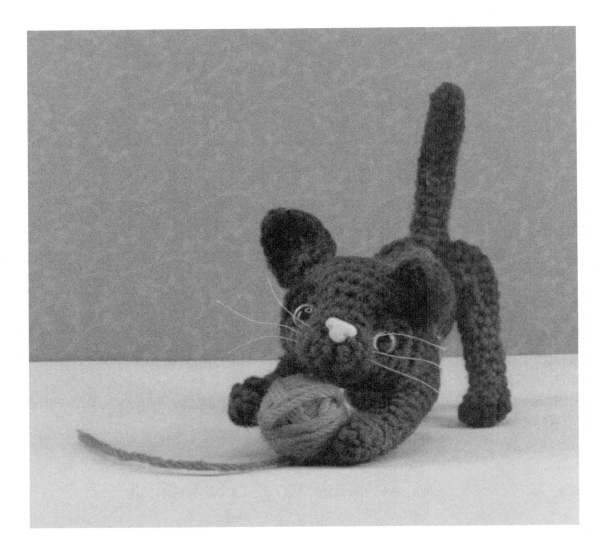

tip
Check out tips and tricks for embroidered noses and muzzle shaping on **pgs 18–19**. Refer to "Straighter Seams in the Round" on **pg 12** to help keep your cat's head shaping from twisting as you work!

HEAD
With grey, make a 4-st AR.

Rnd 1: Hdc 2 in next st*, sc 2 in next 2 sts, hdc 2 in next st*. (8 sts)

Rnd 2: Hdc 2 in next 2 sts*, sc 4, hdc 2 in next 2 sts*. (12 sts)

Rnd 3: Sc2tog 2 times, sc 2 in next 4 sts, sc2tog 2 times. (12 sts)

Rnd 4: Hdc 2 in next 2 sts, sc 2 in next 2 sts, sc 4, sc 2 in next 2 sts, hdc 2 in next 2 sts. (20 sts)

Rnd 5: (Sc 4, sc 2 in next st) 4 times. (24 sts)

Rnd 6: (Sc 2, sc 2 in next st) 8 times. (32 sts)

Rnd 7: Sc 4, hdc 2 in next 2 sts, hdc 4, sc 12, hdc 4, hdc 2 in next 2 sts, sc 4. (36 sts)

Rnds 8–10: Sc 36.

Rnd 11: (Sc 1, sc2tog) 12 times. (24 sts)

Rnd 12: (Sc 1, sc2tog) 8 times. (16 sts)

Rnd 13: (Sc 2, sc2tog) 4 times. (12 sts)

Fasten off yarn, leaving a long tail for sewing.

The "hdc 2s" from Rnds 1 and 2 will become the lower front edge of the muzzle shaping. PM in middle of muzzle shaping if desired.

Stuff the muzzle and head. If embroidering the nose, see pg 18. If using a 12mm plastic safety nose, attach nose to the front of the muzzle, one rnd above the 4-st AR, with the muzzle shaping pointing down. Position 10mm safety eyes on the sides of the head behind the muzzle.

Remove stuffing, attach the safety eye and nose backings, and then restuff head. Close hole in the back of the head. With black yarn, add a lip cleft to the muzzle, below the nose (pg 19). With black yarn, embroider eyebrows.

With grey yarn and tapestry needle, draw a 10" piece of yarn back and forth through the head in front of the eyes, pulling gently to sink the eyes into the head. When you are happy with the head shaping, secure the yarn and sew in the ends.

Optional: If you would like to add whiskers, cut three 6" pieces of off-white thread and attach under the muzzle using fringe knots. Using a sewing needle or crochet hook, draw the yarn out through the sides of the muzzle.

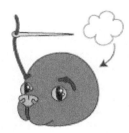

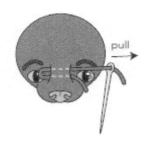

MOUTH

With grey, make a 4-st AR. Do not join. Turn. You will be working a semicircle shape.

Row 1: Ch 1, sl st 1, sc 2, sl st 1. (4 sts)

Fasten off yarn, leaving a long tail for sewing.

Sew the flat edge of the mouth behind the muzzle shaping.

Optional: Glue or sew in a small pink tongue made of felt.

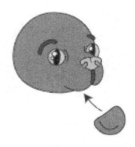

EAR (MAKE TWO)

With grey, loosely ch 5.

Row 1: Starting in second ch from hook, sc 4. Turn. (4 sts)

Row 2: Ch 1, sc 1, sc2tog, sc 1. Turn. (3 sts)

Row 3: Ch 1, sc 1, sk 1, sc 1. Turn. (2 sts)

Row 4: Ch 1, sc2tog, and pm. (1 st)

Continue to sc around the entire edge of the ear until you reach the pm st from Row 4. (Sc 1, ch 2, sl st 1) in pm st. Fasten off yarn in next st, leaving an 8" tail for sewing.

Pin the flat edges of the ears about 4–5 rounds behind the eyes at a slight angle, allowing the points of the ears to stick up. Position both ears before sewing in place to ensure they are attached evenly. Attach with a whip stitch and weave in the ends.

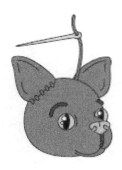

BODY

With grey, make a 6-st AR.

Rnd 1: Sc 2 in each st around. (12 sts)

Rnd 2: (Sc 1, sc 2 in next st) 6 times. (18 sts)

Rnds 3–4: Sc 18.

Rnd 5: (Sc 8, sc 2 in next st) 2 times. (20 sts)

Rnds 6–8: Sc 20.

Rnd 9: (Sc 3, sc2tog) 4 times. (16 sts)

Rnd 10: (Sc 6, sc2tog) 2 times. (14 sts)

Rnds 11–12: Sc 14.

Rnd 13: (Sc 6, sc 2 in next st) 2 times. (16 sts)

Rnd 14: Sc 16.

Rnd 15: (Sc 2, sc2tog) 4 times. (12 sts)

Stuff body.

Rnd 16: Sc 12.

Rnd 17: (Sc 1, sc2tog) 4 times. (8 sts)

Fasten off yarn, leaving the neck edge open. Lightly stuff the upper body and neck. Sew the open edge of the neck to the back of the head. If you have marking or straight pins, use them to help position the head before you sew.

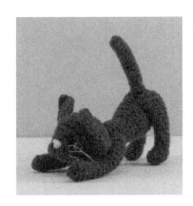

LEG (MAKE FOUR)

With grey, make a 4-st AR.

Rnd 1: Sc 2 in each st around. (8 sts)

Rnd 2: Sc 2, hdc 4*, sc 2. (8 sts)

Rnd 3: Sc 2, sc2tog 2 times, sc 2. (6 sts)

Rnds 4–8: Sc 6.

Rnd 9: (Sc 2, sc 2 in next st) 2 times. (8 sts)

Rnds 10–13: Sc 8.

Rnd 14: (Sc 3, sc 2 in next st) 2 times. (10 sts)

Rnd 15: Sc 10.

Rnd 16: (Sc 3, sc2tog) 2 times. (8 sts)

Fasten off yarn, stuff leg, and close hole, leaving an 8" tail for sewing.

The "hdc 4" from Rnd 2 will become the front of the paw.

With black yarn and tapestry needle, draw the yarn from the bottom of the paw up through the top of the paw. Loop over the front edge of the paw and back to the starting point. Loop around one more time and cinch tightly. Repeat the whole process one more time to form the toes. Repeat on all legs. Weave in the ends.

foot bottom

To attach the front legs, position the legs on the sides of the body with the legs parallel to the bottom of the head. Line up the tops of the legs with the bottom of the neck (Rnd 17). Using a mattress stitch, sew the side edges of the upper part of the legs to the sides of the body.

Angle the back of the body up so it sits higher than the head, and attach the side edges of the upper part of the back legs to the back of the body.

TAIL

With grey, make a 6-st AR.

Rnds 1–14: Sc 6.

Rnd 15: (Sc 1, sc 2 in next st) 3 times. (9 sts)

Fasten off yarn, leaving a long tail for sewing.

Lightly stuff the tail. Use the back of the crochet hook if needed. Sew the open edge of the tail to the back of the body.

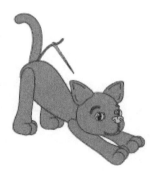

YARN BALL

With purple, make a 6-st AR.

Rnd 1: (Sc 1, sc 2 in next st) 3 times. (9 sts)

Rnd 2: (Sc 2, sc 2 in next st) 3 times. (12 sts)

Rnd 3: (Sc 2, sc 2 in next st) 4 times. (16 sts)

Rnd 4: (Sc 2, sc2tog) 4 times. (12 sts)

Rnd 5: (Sc 2, sc2tog) 3 times. (9 sts)

Stuff yarn ball.

Rnd 6: (Sc 1, sc2tog) 3 times. (6 sts)

Fasten off yarn, leaving a long tail for sewing.

With a 24" strand of purple yarn and a tapestry needle, sew long stitches over the surface of the yarn ball to recreate the look of a wound ball of yarn. Repeat as needed until the ball is covered. After you have fastened off, leave a 4" yarn tail attached to the yarn ball.

Place yarn ball between the front paws of the cat and sew in place with grey yarn.

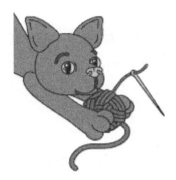

abbreviations

()	Work instructions within parentheses as many times as directed
"	inch(es)
alt	alternate
approx	approximately
AR	adjustable ring
beg	begin(ning)
bet	between
bl	back loop
CC	contrasting color
ch	chain/chain stitch
ch sp	chain space
cont	continue(ing)
dc	double crochet
fl	front loop
g	gram(s)
hdc	half-double crochet
lp(s)	loop(s)
m	meter(s)
MC	main color
mm	millimeter(s)
oz	ounce(s)
pm	place marker
prev	previous
rem	remaining
rep	repeat(s)
rnd(s)	round(s)
RS	right side

sc	single crochet
sc2tog	single crochet 2 together
sk	skip
sl st	slip stitch
sp	space
st(s)	stitch(es)
tbl	through both loops
tog	together
WS	wrong side
yd(s)	yard(s)
YO	yarn over

Printed in Great Britain
by Amazon

37919688R00077